Gallery guide by Louise E. Virgin, Ph. D., Curator of Asian Art, assisted by Susannah Baker, and published to accompany the installation of the Chinese Decorative Arts Gallery.

The installation of the displays and this publication were made possible with additional support from John and Maria Dirlam.

Library of Congress Card No. ISBN # 978-0-936042-25-1

OCLC#
613982993

Design by Kim Noonan
Photography by Steve Briggs

Printed in Canada

Cover images: (left) *Triple Brush Washer in the Shape of Three Peonies*, nephrite, late 18th century, Qing dynasty; Gift of John and Maria Dirlam, 2006.613; (right) *Large Meiping Vase with Sgraffito Design of Peonies*, 11th or 12th century, Northern Song dynasty, Cizhou ware, stoneware with black on white slip under a transparent glaze; Bequest of Margaret C. Osgood, 1958.2 (see pp. 48 and 85)

Inside front cover: Detail of *Vase Stand with Design of Phoenix, Garden Rock Peonies and Magnolia*, Kangxi period (1662-1722), Qing dynasty, porcelain tile with famille noire enamel decoration on teak stand; Museum purchase, 1916.7 (see p.117)

Page 4: Detail of *Flask Vase with Peony Motif*, early 19th century, Qing dynasty, nephrite; Gift of John and Maria Dirlam, 2008.122 (see p. 37)

Inside back cover: Detail of *Dish with the Eight Buddhist Symbols and a Central Floral Scroll Medallion*, Tongzhi period (1862-1874), Qing dynasty, Jingdezhen, porcelain with famille rose enamel decoration over white porcelain glaze; Gift of Mrs. William C. Thompson, 1901.9.2 (see p.123)

Back cover: *Striding Bixie*, nephrite, first half of the 17th century, Ming dynasty; gift of John and Maria Dirlam, 2006.611 (see p.25)

Chinese Art Treasures on Display:
LATER JADES AND CERAMICS
AT THE WORCESTER ART MUSEUM

Louise E. Virgin, Ph.D., Curator of Asian Art
with assistance from Susannah Baker

WORCESTER ART MUSEUM
55 SALISBURY STREET
WORCESTER, MA 01609, U.S.A.
WWW.WORCESTERART.ORG

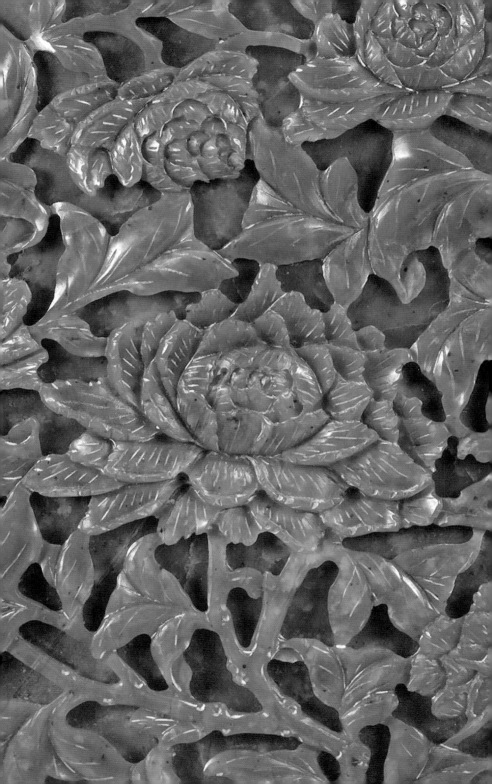

CONTENTS

The Worcester Art Museum is pleased to introduce a new gallery for Chinese decorative arts. Thanks to generous donors who have given from their personal collections as well as funds for the purchase of art, this collection of Chinese jades and ceramics has been in the making for over a century. Some of the works are familiar favorites, while others are finally on display after many years in storage. Thanks to recent research and conservation work, we are now able to present a wide range of work. The installation has been designed both to showcase the beauty of these exquisite pieces as well as to enable visitors to learn from them. We are grateful to the many individuals who have enabled the Museum to present such rich and exciting holdings. I would also like to express appreciation to our staff for their efforts in showcasing these objects in an attractive and engaging installation and in documenting them with this handsome and informative catalogue. Special thanks to our curator of Asian art, Louise Virgin, for overseeing this exciting project.

James A. Welu, Director

PREFACE

This gallery guide is intended to introduce the later Chinese jades and ceramics on display in the Chinese Decorative Arts Gallery at the Worcester Art Museum. It is anticipated that future editions of this guide will be published when the collection grows through future gifts and acquisitions, and as more information comes to light.

The Museum's installation of the gallery has been inspired and supported by generous donations from John and Maria Dirlam, of both elegant jades and funding for the lighting of the cases. Many thanks to the following Worcester Art Museum staff for their expert work: Patrick Brown, Trevor Toney and John Hyden, who designed, built and installed the cases; Steve Briggs for his photography; Deborah Diemente, for kindly sharing her knowledge about ceramics; Professor Emeritus Arthur H. Brownlow for his help in identifying the stones; Paula Artal-Isbrand, Sue Costello and Philip Klausmeyer for their conservation work and analysis of the materials; Kim Noonan, for designing this gallery guide; and Mary Baker for helping with the final editing. Warm thanks also to Susannah Baker, who volunteered numerous hours of research and participated in every aspect of the exhibition, cataloguing, and publication process.

Louise E. Virgin, Ph.D., Curator of Asian Art

CHINESE JADES *and*

OTHER TREASURED STONES

INTRODUCTION

Jade has fascinated the Chinese for thousands of years. It was believed to be a supernatural emanation of mountains and streams, embodying the essence of life, virtue, immortality and nobility. Extremely tough and pure in tone when struck, jade was esteemed as the fairest and most valuable of stones.

Inextricably connected with Chinese culture, jade was laboriously ground and polished into objects of magical, religious, philosophical, and auspicious symbolism. Ancient rulers used ceremonial jades as offerings that enabled communication with heavenly and earthly powers. The possession and awarding of such jades also invested noblemen with rank and authority. The earliest jade objects, found in tombs dating from the late Neolithic period through the Han dynasty (ca. 2500 BCE–220 CE), include ceremonial disks, tools, talismanic pendants, and sculptures of mythological beasts and real animals.

The mystique and beauty of ancient jades, as well as the association from the 5th century BCE onwards of jade with Confucian virtues and Taoist immortal realms, inspired archaistic revivals during later centuries. Many early patrons and collectors of jade could be found at the imperial court. From the late 18th to the early 20th century, interest in sculpting jade and other stones of varied colors was unparalleled in any other culture. Respecting the original forms of the stones, artisans created elegant accessories and sculptures using sand abrasives with treadle wheels and hand-driven borers and drills. These objects were destined for the desks and display shelves of courtiers, officials, scholars and the increasingly wealthy bourgeoisie. Contemporary jade artisans continue to create spectacular works, often using power tools and synthetic abrasives.

The collection of later jades at the Worcester Art Museum has been formed mainly through the generosity of passionate jade collectors: Harry W. Goddard (1863–1927) and his wife Grace (1866–1935), and John and Maria Dirlam. The Museum's collection of ancient jades has recently been enhanced by gifts of rare works from the collections of the Dirlams, Drs. Ann and Robert Walzer, and from the Rubin – Ladd Foundation: Ester R. Portnow Collection of Asian Art. These ancient jades will be displayed in a neighboring gallery.

The Chinese have always revered antiquity. There were three main waves of archaism: the first during the Song-Yuan dynasties (ca. 11th–14th centuries); the second during the Ming dynasty (1368–1644); and the third during the Qing dynasty (1644–1911). The powerful Manchu ruler Qianlong (r. 1736–95) was not only passionate about jade but also a connoisseur of antiquities. Taking military control of the western Xinjiang province in the late 1750s, Qianlong secured a flow until 1821 of tribute gifts of nephrite boulders gathered in the Kunlun Mountains. The emperor also facilitated the importation of nephrite from Siberia and established friendly relations with Myanmar (Burma) in 1784, enabling the steady procurement of jadeite.

Aiming to "restore the ancient ways," the Qianlong emperor encouraged his artisans to use antique bronzes and jades in the imperial collection as inspiration for their works in jade and other treasured stones. Some revival vessels were close copies of ancient forms, but most were creative amalgamations of the shapes and motifs of earlier eras. Some works were placed on family altars while others functioned as decorative vases and containers.

The Ming and early Qing dynasty wave of archaism inspired a revival of interest in mythological creatures. Jade carvers delighted in rendering small sculptures of dragons, phoenixes, *qilin* and *bixie* or in using these creatures as ornamental motifs on objects destined for the desks and display shelves of court officials, scholars and wealthy merchants. The varied artistic interpretations of the beasts were often copied from or freely inspired by antique collectibles reproduced in woodblock-printed manuals published to promote good taste.

Scholars who hoped to gain positions in the Confucian bureaucracy were required to take civil service examinations. Only the wealthy had the time and means to memorize classical texts related to the teachings of Confucius (551–479 BCE) and gain the skills needed to pass the tests. Successful scholars gained access to the highest social, economic and cultural spheres; they could even become powerful officials at the imperial court. Scholars strove to live by moral precepts and valued jade as a stone with qualities (luster, translucency, pure tone, tough compactness, angularity without sharpness) that exemplified the five virtues of a perfect Confucian gentleman (charity, rectitude, wisdom, courage and justice).

Each scholar-official usually had a home study with wooden cabinets, chairs and a desk arranged to view a private garden. Proficient in the "three perfections" (calligraphy, poetry and painting), they relied on "the four treasures" (brushes, paper, ink and ink-stone). From the Song dynasty (960–1279) onwards scholars were avid collectors of desk accessories such as table screens, water droppers to dilute the ink, as well as brush holders, rests, and washers. These accessories were often made of jade or other semiprecious stones. Embellished with symbolic imagery, they were selectively displayed during different seasons, providing philosophical inspiration and topics of conversation.

Sculptures of revered figures were often commissioned as gifts to symbolize wishes for success, happiness, long life and spiritual development. Used as decorative objects to be placed on tables, shelves or writing desks, they reflect the eclecticism of Chinese taste, culture, moral thought and religion. Virtuous Confucian scholars, eccentric Taoist gods and immortals, and Buddha's enlightened disciples were frequently depicted amidst lofty mountains. Graceful and compassionate Taoist and Buddhist female figures were also portrayed, sometimes with a fusion of symbolic attributes.

During the 18th and early 19th centuries the understated naturalistic style of the earlier Ming dynasty (1368–1644) became increasingly elegant and realistic in detail. Objects featuring plant and animal subjects, usually conferring symbolic wishes for male descendants and a long, abundant life, were made larger, more extravagant and polished. Some works reflect Qianlong's admiration for the intricately linear yet organic surface decoration of works created in Hindustan for Muslim Mughal rulers. Mughal jades came into China as tribute gifts from 1758 onwards, and Muslim jade carvers were brought to the imperial workshops to fashion similar wares. Chinese craftsmen copied and were creatively inspired by these objects. The results were often hybrid vessels of traditional Chinese shapes transformed by overall floral relief and pierced openwork.

The Chinese term *yu* refers to a number of finely grained stones that will take a high polish, such as, nephrite, jadeite, bowenite, serpentine, rock crystal, agate, lapis lazuli and turquoise. The English word "jade" only refers to two minerals, nephrite and jadeite. Considered by the Chinese to possess supernatural powers and to exemplify spiritual virtues, nephrite has been used since the Neolithic period to create ritual implements and other treasured objects. Jadeite was rarely seen before the end of the 18th century when it was imported in great amounts from Burma. Magnification reveals that the crystals in nephrite take on an interwoven fibrous structure while in jadeite the crystals are separate yet interlocking granular entities. Polished nephrite generally has a silkier, greasier looking surface while jadeite has a more vitreous, lustrous surface.

Nephrite is considered to be the mineral actinolite, although lighter shades of nephrite have more the composition of the mineral tremolite. Both actinolite and tremolite are calcium magnesium silicates, with actinolite also containing iron. Nephrite occurs in varied colors including white, pale green, gray-green, spinach-green, yellow and russet. The coloration is due to varying amounts of the naturally occurring iron and of chemical impurities. Nephrite is only moderately hard (6–6.5 out of 10 on the Mohs Hardness Scale) but it is extremely tough (i.e., resistant to crushing or breaking).

Jadeite is a silicate of sodium and aluminum. Formed under high pressure, it is a very tough and dense mineral although it is only moderately hard (6.5–7 on the Mohs Hardness Scale). Jadeite is rarer than nephrite and is often used to make jewelry. It occurs in a great variety of colors including white, apple green, imperial green, gray-green, blue, violet, purple, yellow and pink. The colors are due to the presence of chemical impurities such as chromium and iron.

From the late 18th to the early 20th century, the Chinese interest in sculpting a wide variety of beautiful stones was unparalleled in any other culture. While jade was held in greatest esteem, the Chinese also worked with other stones, especially those of interesting colors or patterns. Agate, amber, amethyst, carnelian, chalcedony, coral, lapis lazuli, malachite, rock crystal, rose and green quartz, sodalite and turquoise were all used, particularly during the reign of the Qianlong emperor (1736–95) and later. Consisting of small to microscopic crystals (aggregates), these stones have the hardness (i.e., resistance to scratching or abrasion) of 7 or less on the Mohs Hardness Scale. The lower the hardness of the stone, the easier it is to shape by grinding and/or by carving and engraving.

The making of a jade object may take thousands of hours to complete. In its natural uncut state, jade (nephrite and jadeite) is embedded in nondescript boulders. Jade "carvings" are actually shaped through laborious cutting, grinding and polishing with abrasives. Since nephrite and jadeite have the hardness of 6–6.5 and 6.5–7 on the Mohs Scale they can only be abraded by sands made of harder stones such as quartz (7), almandine garnet (7.5), and corundum (9). By the 20th century, the synthetic material carborundum, with a hardness of 9.5, had replaced corundum.

The process of creating jade objects was documented by artist Li Shichuan in watercolors that were included in a rare two-volume book by Heber R. Bishop entitled, *Investigations and Studies in Jade* (New York, 1906; issued in 100 copies). His illustrations depict the manufacture of jade objects in an era before power tools and synthetic abrasives. The main steps are summarized below.

1. Sand had to be prepared for use as an abrasive before any work could begin. Sand was ground and pounded until it reached the appropriate consistency. Different kinds of abrasive sands were identified for different purposes.

2. When a workshop obtained a jade boulder, its flaws and coloration were studied. The artist or head of the workshop then determined the kind and number of objects the boulder could produce and where it should be cut. Large boulders of crude jade were cut into the number of required pieces, removing any non-jade stone. Rough cutting was done by two men pushing and pulling a two-handled, steel-wire saw mounted on a taut bamboo frame, an operation that could take weeks or months. The saw was kept moist with a wet abrasive paste of black sand made of corundum.

3. An artist studied a chosen jade piece and added ink designs onto the stone. An artisan then cut the jade piece along the desired lines by operating a treadle that drove a cutting wheel. The artisan added an abrasive of red wet sand made of garnets to the surface to be cut. The artist watched for flaws or color changes that would have to be incorporated into the design. When needed, the artist re-inked the piece.

4. The piece subsequently went to an artisan who operated a succession of large and small treadle wheels that further shaped as well as polished the surface of the jade work.

5. The next steps depended on the design of the piece and on the collaboration of the artist and craftsmen. All cutting was done with abrasives and specialized equipment. Surface relief designs were carved with small, round treadle-driven steel disks. Hollowing out vases and bowls was done with a tubular steel borer mounted on an iron rod, creating a core that later could be removed with a hammer and chisel. Artisans executed detailed openwork with bow saws. One of Li Shichuan's illustrations shows a jade piece held in place in a bamboo bucket being pierced by means of hand-operated diamond drills.

6. Jade works were given a final polish using sandalwood grinding wheels with abrasives as well as leather-buffing wheels. Hard-to-reach areas were rubbed with small leather plugs. Every scratch and sharp angle was removed before the object was considered finished.

Glossary of Materials

During the 18th century, the court taste became eclectic under the patronage of the Qianlong emperor. Artisans who worked with jade (nephrite and jadeite) also created objects out of other stones with unusual colors. The Worcester Art Museum's permanent exhibition features objects made of the materials listed below. Their relative hardness (i.e., resistance to scratching or abrasion) is indicated using the Mohs Hardness Scale (talc is 1 and diamond is 10).

Agate is a form of chalcedony, a translucent to transparent milky quartz with distinctive microscopic crystals. It is characterized by bands of different shades and translucency. These bands blend into clouds or moss-like forms. Agate occurs in many colors and is quite hard (7 on the Mohs Scale). It was worked by the Chinese in the same way as jade, but does not have the symbolic virtues attributed to jade. Its Chinese name, "horse brains" (*manao*), was derived from its pattern.

Carnelian is a pale to deep red to orange form of chalcedony, a variety of quartz. It is quite hard (7 on the Mohs Scale) and has been used in China since ancient times.

Coral is an underwater deposit consisting of calcareous skeletons of various marine organisms. Its color ranges from white to red to black. It is a fairly soft material (3.5 on the Mohs Scale) and can be fashioned with primitive tools (i.e., knife, file, drill and grindstone). Chinese legend says that coral comes from a tree that grows at the bottom of the sea and only blooms once each century. It therefore became an emblem of longevity and official promotion and was a highly favored material during the Qing Dynasty (1644–1912).

FLUORITE is prized for its glassy luster and rich variety of color. It comes in purple, blue, green, yellow, brown, pink, black and reddish orange as well as a colorless variety. Most specimens of fluorite show a single color but others may include multiple colors arranged in bands. Some specimens are also fluorescent and/or phosphorescent. Fluorite is somewhat soft (4 on the Mohs Scale).

JADE is a term that refers to both nephrite and jadeite. Both are very tough (i.e., resistant to crushing or breaking) but soft enough to be fashioned by grinding. Both stones consist of individual crystals; magnification reveals that the crystals in nephrite take on an interwoven fibrous appearance while in jadeite the crystals are separate, yet inter-locking entities. The surface of nephrite generally has a silkier, greasier surface while jadeite looks grainier and has a more vitreous, lustrous surface. Nephrite (from mountainous western China and Siberia) has a long history in China; jadeite was rarely used before the late 18th century when imported in great amounts from Burma. There are trade names for the many colors of jade; the translucent "mutton fat" or dark "spinach-green" nephrite and "apple-green" and "imperial green" jadeite were especially appreciated.

JADEITE is a silicate of sodium and aluminum and is granular in structure. Formed under high pressure, it is a very tough and dense mineral, but only moderately hard (6.5–7 on the Mohs Scale). Polished jadeite is translucent with a vitreous surface. It occurs in a greater range of colors than nephrite (i.e., white, shades of green, blue, lavender, purple, yellow and pink). The colors are due to the presence of chemical impurities, including iron and chromium. Jadeite was not commonly used in China until the late 18th century.

LAPIS LAZULI is a rock composed mainly of lazurite but also of pyrite, calcite and other minerals. The brilliant blue lazurite gives the stone its color. Lazurite has a medium hardness (5–5.5 on the Mohs Hardness Scale) and a vitreous to greasy surface. Because lapis contains minerals of differing hardness, polishing may result in an uneven surface. Lapis lazuli was imported from Afghanistan and Tibet as early as the Tang Dynasty (618–906).

NEPHRITE is considered to be the mineral actinolite although lighter shades of nephrite have more of the composition of the mineral tremolite. Both actinolite and tremolite are calcium magnesium silicates. Nephrite is fibrous in structure and occurs in a variety of colors including white, light green, gray-green, dark green, yellow and russet; the coloration is due to varying amounts of the naturally present iron and of chemical impurities. Surface discoloration occurring in certain nephrite boulders is often incorporated into the design of objects.

Polished nephrite can be translucent to opaque and has a silky, slightly waxy surface. Nephrite is only moderately hard (6–6.5 on the Mohs Scale); it is, however, extremely tough—actually tougher than jadeite and stronger than steel. Held in higher esteem than gold or jewels, nephrite has been worked in China since the Neolithic period.

QUARTZ is the most common mineral on earth and also the most varied in type, color and form. It can be transparent, translucent or opaque and has a vitreous to waxy luster. Among the more prized varieties of quartz are amethyst, agate, carnelian, citrine, onyx, rock crystal and rose quartz. Quartz is quite hard (7 on the Mohs Scale).

ROCK CRYSTAL is a colorless, transparent variety of the mineral quartz. Like all quartz, it is quite hard (7 on the Mohs Scale). The Chinese name for rock crystal (*shuijing*) means "water essence" and it is considered a symbol of sacredness and perfection, with the ability to ward off evil and bring luck.

TURQUOISE is a blue to blue-green mineral containing aluminum, copper and phosphorous. It is opaque with a vitreous to waxy surface and has a medium hardness (5–6 on the Mohs Scale); it is also porous and very sensitive to heat and chemicals. Turquoise was very popular during the earliest periods of Chinese history when it may have been found locally. After the Han dynasty the only sources of turquoise seem to have been Mongolia and Tibet. Turquoise was used during the Yuan (1279–1368) and the Qing dynasties (1644–1911), especially during the reign of the Qianlong emperor (1736–95).

Note: *The initial identification of the stones was accomplished by Dr. Arthur H. Brownlow, Professor Emeritus of Geology (Boston University) and a gemologist. They were further analyzed by means of energy dispersive x-ray flourescence (ED-XRF) by Dr. Philip Klausmeyer, Andrew W. Mellon Conservator in Painings and Conservation Science at the Worcester Art Museum.*

Vase in the Shape of a Bronze Ritual Vessel (ku)
Pale grayish-green nephrite
Qianlong period (1736–1795), of the Qing dynasty (1644–1911)
Incised square six-character (seal script) mark:
Da Qing Qianlong nian zhi ("Made in the Qianlong reign")
Gift of John and Maria Dirlam, 2007.240

During the 18th century, artisans of the imperial workshops created many vases inspired by the shapes and decoration of ancient bronze vessels. Such bronzes were used in rituals to commemorate important events of state and to honor ancestors. As emblems of sovereignty, power, and wealth, the bronzes were also buried with royalty and nobility. This archaistic nephrite vase is shaped like an ancient bronze *ku* with stylized beast masks and a squared spiral fret pattern. The motif of bats, symbols of happiness and longevity, was a fashionable addition.

Small Incense Burner
Whitish nephrite
18th century, Qing dynasty (1644–1911)
Bequest of Mrs. Harry W. Goddard, in memory of Harry W. Goddard,
1938.48

Eighteenth-century jade carvers were inspired by, but not limited by, the past. Carved out of rare whitish nephrite, this revival-style censer is reminiscent of both a square archaic bronze *fang-ting* food vessel and the lid of a bronze *fang-i* wine vessel. The sides of the incense burner are decorated with C-shaped volutes and dots that harken back to ancient metalwork and jade designs. The Buddhist lion-dog on the lid and the lion-head handles were fashionable innovations.

Small Incense Burner with Lid, in the Shape of a Bronze Tripod (ding)
Yellowish nephrite
18th century, Qing dynasty (1644–1911)
Bequest of Mrs. Harry W. Goddard, in memory of Harry W. Goddard, 1938.52

This incense burner is shaped like a *ding*, an ancient bronze vessel that looks like a cauldron with three legs. Made of a rare yellowish jade, the censer has dragonhead-and-ring handles and a lid surmounted by a Buddhist lion-dog. Legs emerge from the mouths of lion-dog heads.

Lion-dogs are thought to be a combination of the regal lion of early Indian culture and the celestial dogs of ancient Chinese mythology. Sacred to Buddhism and known in the West as *fo* or *fu* (Buddha) dogs, sculptures of paired male and female lion-dogs were placed as guardians outside Chinese Buddhist temples and halls. As Buddhism flourished during the Ming and Qing dynasties, lion-dogs became a favorite artistic subject and decorative motif.

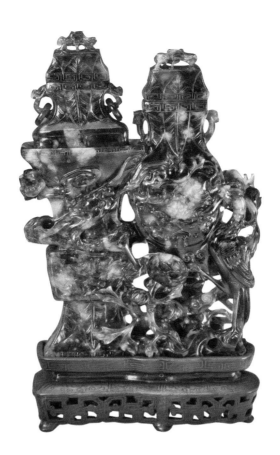

Double Vase with Lids, in the Shape of Bronze Ritual Vessels (hu and ku)
Dark green jadeite with white inclusions
Late 18th century, Qing dynasty (1644–1911)
Bequest of Mrs. Harry W. Goddard, in memory of Harry W. Goddard,
1938.66

The shapes employed in this double vase refer to archaic bronze vessels, but its
playful and sophisticated style exemplifies 18th-century taste. The shorter side
of the double-vase is shaped like a *hu* vessel; the taller side shows a *hu* emerg-
ing from a *ku* shape. A dragon (a symbol of the emperor) chasing a flaming
jewel and a phoenix (symbol of the empress) holding a peony spray in its beak,
enliven the front surface of the vessel.

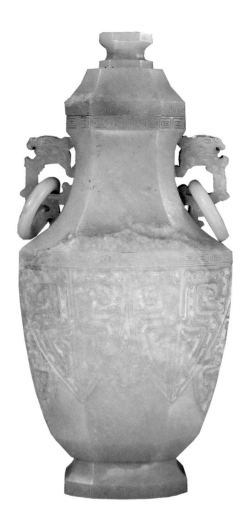

Vase with Lid, in the Shape of a Bronze Ritual Vessel (hu)
Pale grayish-green nephrite
18th century, Qing dynasty (1644–1911)
Gift of John and Maria Dirlam, 2008.121

This lidded vase is conceived in the flattened shape of a bronze *hu* vessel. The handles are reminiscent of ancient jade dragon pendants, and the hanging shields, carved in low relief below the shoulder of the vessel, echo their design. Four bands of squared fret design also adorn the vase.

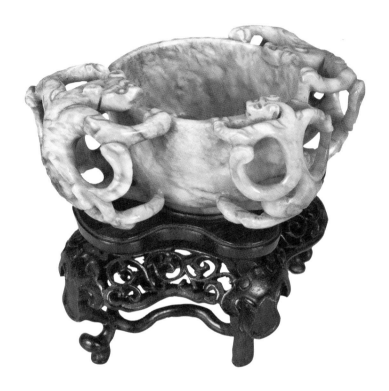

Small Cup with Three Qi-dragon Handles
Mottled tan nephrite
Early 17th century, Ming dynasty (1368–1644)
Bequest of Mrs. Harry W. Goddard, in memory of Harry W. Goddard, 1938.62

Young, hornless *qi* dragons with branched tails first appeared in works of the Han dynasty (206 BCE–220 CE). They can, however, be traced further back to the animal motifs on metal artworks of the steppe nomads along China's western borders. From the 12th century onwards *qi* dragons were a popular archaistic motif; they often formed the handles of vessels or were shown play-fully chasing jewels or each other.

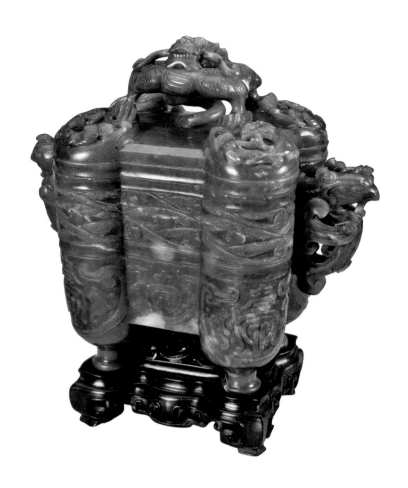

Incense Burner with Lid, in the Shape of a Bronze Color-Mixer
Spinach-green nephrite
18th century, Qing dynasty (1644–1911)
Bequest of Mrs. Harry W. Goddard, in memory of Harry W. Goddard, 1938.34

Jade artisans skillfully transformed the forms and decoration of archaic bronze vessels into quintessentially Qing dynasty treasures, often made to commemorate special occasions. The shape of this archaistic incense burner is reminiscent of ancient bronze color-mixers used to store artist-paints in the cylindrical legs (closed by wooden stoppers) and to mix paint in a central water saucer. The lid has a central knob in the shape of a large coiled dragon that plants its outstretched paws on four young dragons. The sides of the censer are embellished with phoenix-shaped handles as well as low-relief patterns of serpentine animals and variations of the character for longevity (*shou*).

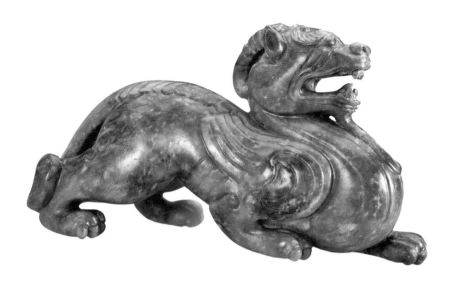

Striding Bixie
Pale green nephrite with russet areas
First half of the 17th century, Ming dynasty (1368–1644)
Gift of John and Maria Dirlam, 2006.611

Bixie ("ward off evil") are known as protective, mythical feline creatures with paws, wings, flames, horns, divided tails and bulging eyes. Derived from Persian sources (the lion and the winged leonine chimera), *bixie* were often placed in pairs in tombs or at the start of the pathways leading to Han and Six Dynasties' tombs in order to shield the dead from malevolent spirits. This archaistic work shows the beast aggressively snarling and striding, emulating early renderings of *bixie*.

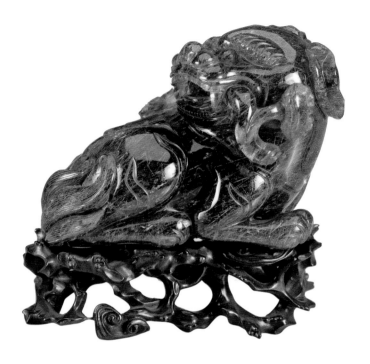

Bixie with a Spray of Lingzhi Fungus in its Mouth
Brown quartz with rutile inclusions
18th century, Qing dynasty (1644–1911)
Bequest of Mrs. Harry W. Goddard, in memory of Harry W. Goddard, 1938.27

During the Qing dynasty, sculptures of the evil-averting *bixie* were created using many different stones and with varied interpretations of its physical appearance. This seated quartz *bixie* is depicted with a single horn, big ears, bushy eyebrows, square snout, mane and tripartite tail. It holds a spray of the fungus of immortality (*lingzhi*) in its mouth, a motif repeated on the wooden stand simulating intertwined roots. The sacred, legendary *lingzhi* is very similar in appearance to the real-world fungus known as *Daedaleopsis confragosa*.

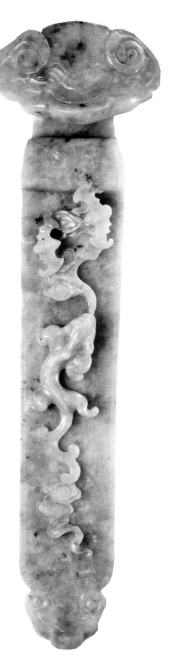

Ruyi Scepter with Qi Dragon and Bats
Pale green jadeite
Late 19th–early 20th century
Gift of John and Maria Dirlam, 1999.440

Since "*ruyi*" could be interpreted as "May you have…" and *lingzhi* is the name for the fungus of immortality, the gift of a *lingzhi*-style *ruyi* scepter implied the wish that the recipient would be granted immortality. Qianlong (r. 1736-95) and succeeding Qing dynasty emperors awarded jade *ruyi* scepters to loyal subjects for meritorious service and to honor visiting dignitaries. This *lingzhi*-style *ruyi* scepter is decorated with two bats (*fu*) hovering over rain clouds that emerge out of the mouth of a *qi*-dragon. It expresses wishes for a long life with double happiness (*fu*), vast to the heavens (*shuang fu*; *hong fu qi tian*).

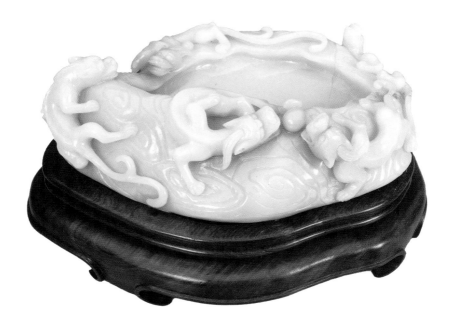

Brush Washer with Five Qi Dragons and Clouds
Pale green nephrite
19th–20th century
Gift of John and Maria Dirlam, 2008.120

Brush washers with dragons clinging to their sides were made as early as the 13th century. During the Ming dynasty (1368–1644) such dragons appeared to emerge from waves which were present on both the interior and exterior of the brush washers. By the Qing dynasty (1644–1911), the waves had mostly been eliminated or, as in this case, replaced by clouds.

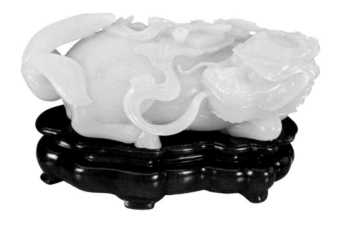

Qilin with Divine Law Books
Pale green nephrite
18th century, Qing dynasty (1644–1911)
Gift of John and Maria Dirlam, 2009.153

Along with the dragon, phoenix, and tortoise, the *qilin* is one of the four great mythical animals. The *qilin* is endowed with the head of a dragon, scales of a fish, antlers of a deer, hooves of a goat, and bushy tail of a lion. It is thought to walk on grass without trampling it and cross water without sinking. The swirling smoke that emerges from its mouth to elevate a bundle of divine law books conveys that the *qilin* is as an omen heralding the birth of a virtuous sage or the beginning of a righteous administration. Since the *qilin* is also an emblem of serenity, goodness and filial piety, its horns are tied with a bow.

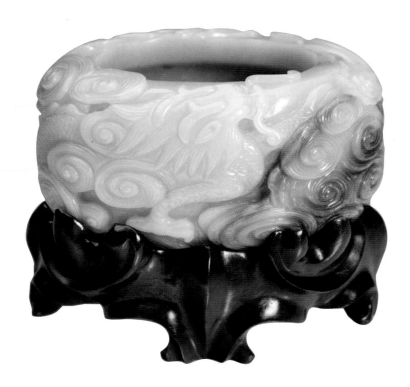

***Oval Water Vessel with Relief Design of Two Dragons amid Swirling
Storm Clouds***
Pale green nephrite with brown areas
Late 18th century, Qing dynasty (1644–1911)
Gift of John and Maria Dirlam, 2007.239

The compact shape of this elegant vessel honors the form of the jade boulder
from which it was made. The dark brown areas in the stone were used by the
carver to emphasize the storm clouds swirling around the dragons.

According to Chinese legend, dragons live in water but each spring rise up
from lakes, rivers and oceans into the sky creating the storms clouds that bring
rain to the rice fields. These benevolent creatures are bringers of good fortune
and serve as intermediaries between heaven and earth. The first emperor of the
Han dynasty (206 BCE–220 CE) claimed that his father was a dragon. From
that time onwards, the dragon was used as a symbol of the Chinese emperor.

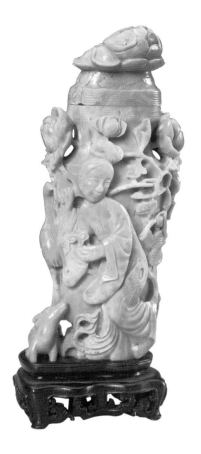

***Covered Vase Decorated with Female Figure Holding Lingzhi Fungus
and Peony Branch, Accompanied by a Boy, a Crane and a Deer***
Coral
18th century, Qing dynasty (1644–1911)
Bequest of Mrs. Harry W. Goddard, in memory of Harry W. Goddard, 1938.70

Coral is found in colors that range from white to red to black. According to
Chinese legend coral comes from a tree that grows at the bottom of the sea
and blooms once each century. As an emblem of longevity and official promo-
tion, coral was highly favored during the Qing dynasty. The identity of this
female figure, who wears a jade disk hanging from her waistband, is unclear.
She could be the beautiful and compassionate Ma Gu who is often depicted
accompanied by a deer.

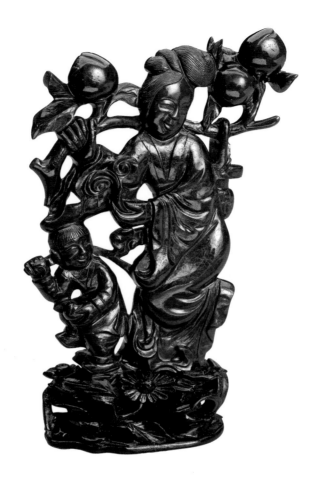

***Female Figure Holding Lingzhi Fungus and a Branch of Ripe Peaches
and Basket, Accompanied by a Boy***
Dark green jadeite
Late 18th century, Qing dynasty (1644–1911)
Bequest of Mrs. Harry W. Goddard, in memory of Harry W. Goddard, 1938.40

Female goddesses, heavenly maidens and fairies with flowing robes are preva-
lent in Taoist and Buddhist myths. Widely popular, their attributes have over
time been fused, making it difficult to identify them in artistic renderings. This
figure could be Xi Wangmu, the Taoist Queen Mother of the West, or the Taoist
immortal Ma Gu—or conflations of both figures. According to legend, the vir-
tuous Xi Wangmu confers immortality by distributing the peaches she grows
in her jade-palace garden. Ma Gu, a symbolic protector of women, is usually
shown carrying a basket.

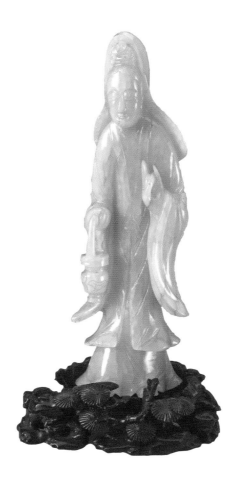

Guanyin
Pale green nephrite
First half of the 18th century, Qing dynasty (1644–1911)
Bequest of Mrs. Harry W. Goddard, in memory of Harry W. Goddard, 1938.71

Guanyin (Sanskrit: Avalokitesvara, "the one who listens to the world") is the Buddhist Bodhisattva of Compassion, an enlightened deity who abstained from entering Nirvana in order help suffering mortals. Early Chinese depictions showed Guanyin as a male figure. By the 12th–13th century Guanyin had been transformed into a beautiful bare-footed woman. As here, Guanyin is often shown with a head covering, a vessel with a lotus design (signifying her ability to help believers conceive sons), and a small image of Amitabha (the Buddha of Boundless Light who presides over the Western Paradise) in her diadem. Guanyin raises her left hand in the gesture for warding off evil.

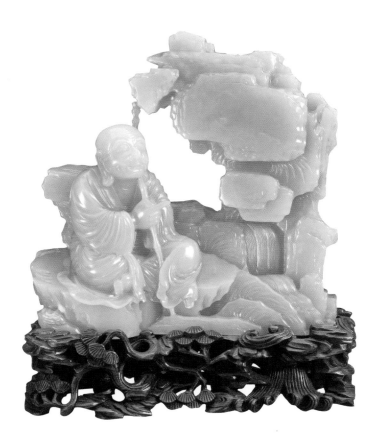

Buddhist Monk (Lohan) with Staff Meditating Near Mountain Stream
Pale green nephrite
18th century, Qing dynasty (1644–1911)
Bequest of Mrs. Harry W. Goddard, in memory of Harry W. Goddard, 1938.67

Lohan (Sanskrit: *arhat*) are Buddha's enlightened disciples who remained on earth to protect and promote Buddhism. In China the original sixteen *lohan* were expanded to eighteen, and later to five hundred. Chinese interest in *lohan* originated with a 7th-century text-translation by the monk-pilgrim Xuanzang (ca. 596–664). Pictorial archetypes of the *lohan* derive from 9th-century paintings by the monk Guanxiu (832–912). From the 11th century onward the figures were usually depicted living in remote mountain settings. Early *lohan* paintings were popularized though woodblock-printed reproductions. These, in turn, inspired the making of sculptures, such as the work shown here, during the revival of Buddhism in the late Ming and early Qing dynasty. Suggesting a nature setting, the carved wooden stand is embellished with pine, plum and bamboo (the "Three Friends of Winter"), and a small waterfall.

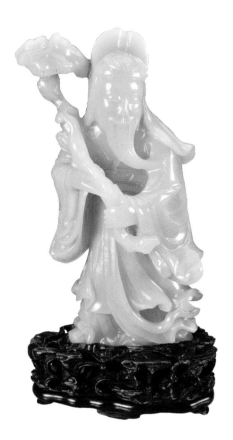

Scholar with a Lingzhi-style Ruyi Scepter
Pale green nephrite
18th century, Qing dynasty (1644–1911)
Bequest of Mrs. Harry W. Goddard, in memory of Harry W. Goddard, 1938.30

This figure represents a scholar holding a scepter shaped like *lingzhi,* the fungus of immortality. During the Ming dynasty (1368–1644) such scepters were usually made of wood and carved naturalistically. During the Qing dynasty, scepters were also made of jade and ivory and embellished with more varied motifs. Presented as gifts, scepters were considered elegant additions to the scholar's desk.

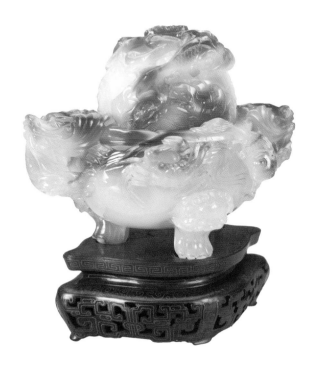

Censer Decorated with Goldfish, Eel, Crabs, Frog, Crayfish and Shells
White and russet agate
18th century, Qing dynasty (1644–1911)
Bequest of Mrs. Harry W. Goddard, in memory of Harry W. Goddard, 1938.64

The surface of this incense burner is enlivened by incised waves and high relief decoration of animals, implying wishes for affluence and achievement. The word for crab (*xie*) is symbolic of scholars who have passed the first civil service examinations towards official rank (*xie*). The word for goldfish (*jinyu*) is similarly a homophone for "gold in abundance" (*jinyu*).

The artisans who created this censer endowed it with dragon handles, playfully emphasizing the archaic origins of incense burners. They also skillfully used the russet areas of the agate to highlight the animals. The breeding of goldfish into exotic forms became a craze in the 18th century.

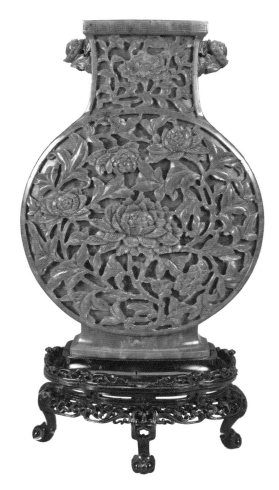

Flask Vase with Peony Motif
Spinach-green nephrite
Early 19th century, Qing dynasty (1644–1911)
Gift of John and Maria Dirlam, 2008.122

The Mughal Kingdom in northern India had an important jade carving tradition. The Qianlong Emperor (r. 1736–95) was so impressed with the naturalism, polish and thin walls of the Mughal jades that he wrote sixty-four poems in praise of the "Hindustan" jades and had various pieces copied in his workshops. Chinese artisans adapted the Mughal style, which continued to be seen in Chinese jades into the 20th century. This flask in spinach-green nephrite reflects the influence of the surface-style decoration of Mughal jades that was imbued with a Chinese sensibility by artisans of the imperial workshops.

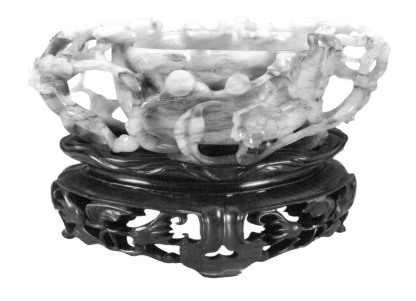

Peach Cup
Grayish green nephrite with brown veins
Early 17th, Ming dynasty (1368–1644)
Bequest of Mrs. Harry W. Goddard, in memory of Harry W. Goddard, 1938.68

Shaped like a peach of immortality, the cup is surrounded by intricate open-work depicting foliated and blooming peach branches, *lingzhi* fungus, pine needles and a *qi* dragon. Since "peach" (*tao*) is a homophone for the word "expel" (*tao*), peach blossoms and peaches are traditionally associated with driving out evil.

The wooden base is carved with a motif of finger citrons, a fragrant fruit with supple tendrils that is popularly called Buddha's Hand (*fushou or foshou*). Regarded as a symbol for happiness (*fu*) and longevity (*shou*) as well as appreciated for its lemon-like odor, the Buddha's-hand citron (*citrus medica*) is often placed as an offering on Buddhist altars or used for scenting rooms.

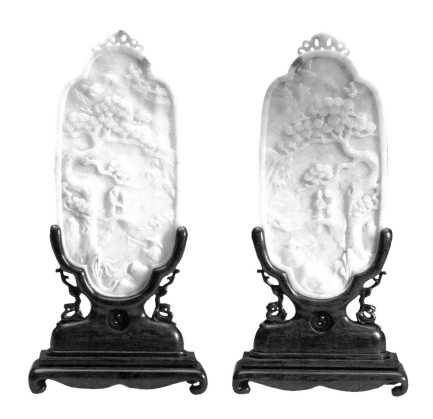

Pair of Screens with Figures in a Landscape
Whitish jadeite with hints of green and pale lavender
20th century
Gift of John and Maria Dirlam, 2001.454.1–2

An important category of jade production was *huayi* ("jades imitating pictures"). The Qianlong Emperor (r. 1736–95) rated *huayi* as highly as *fanggu* ("jade imitating antiques") and encouraged the production of a great variety of *huayi,* including jade boulders, brush pots and screens (e.g 1997.137; 1996.130; 1999.433; 1996.131).

These 20th century *huayi* screens, depicting lovers on a bridge, would have made an ideal wedding gift. The pine and bamboo which frame the scene represent longevity and fidelity. The two magpies flying above the couple symbolize "double happiness" since the first character for the term "magpie" (*xieque*) is the same as that for the word "happiness" (*xi*).

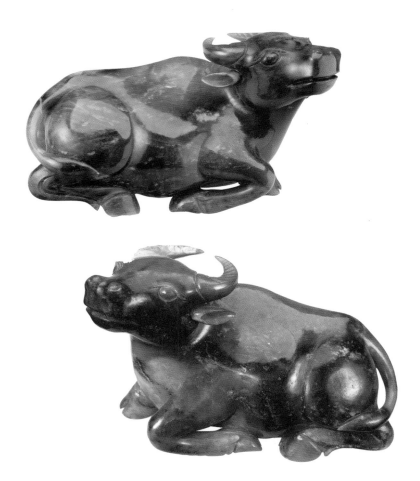

Pair of Large Water Buffalo
Dark green and light brown nephrite
18th century, Qing dynasty (1644–1911)
Gift of John and Maria Dirlam, 2006.612. 1-2

In early times water buffalo were sacrificed in religious ceremonies. Bovine masks were also depicted on ancient bronzes and jades. Honored for its work pulling the plows in the rice fields, the buffalo later became a symbol for a fertile spring and abundant year. The animal is also associated with Taoism sinceits legendary founder, Laozi (7th century), toward the end of his life, is said to have left China riding westwards on a water buffalo. As a Taoist emblem the strong and docile water buffalo symbolizes a rustic, vagabond life in harmony with nature and free of worldly concerns. Shown lying dowm, these jade buffalo represent the world at peace.

Pair of Vases with Lids and Chains
White jadeite with areas of green and hints of lavender
19th century, Qing dynasty (1644–1911)
Gift of John and Maria Dirlam, 2002.550. 1-2

The size and elegance of these vases suggest that they may have been commissioned as a gift for a highranking court official. While vaguely reminiscent of the shape of archaic bronze *hu* vessels and the floral decoration of Mughal jades, the sensibility and motifs of the vases are quintessentially 19th century Chinese.

Each thin-walled vessel, with its lid, ring handles and chains, is carved out of a single jadeite boulder. The lavender tints and apple-green splotches harmonize with the pierced and relief decoration of plum blossom branches, magpies and peonies. Plum blossoms (*mei*) are symbolic of winter and perseverance: they appear on old, bare branches, announcing the arrival of spring. Magpies (*xieque*) derive their good omen connotation from the word for happiness (*xi*). The pictorial puzzle formed by the combination of plum blossoms and magpies expresses the wish for "happiness up to one's eyebrows" (*xi zai mei shao*).

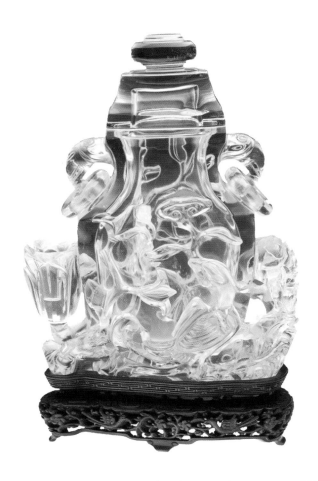

Hu-shaped Vase with Lid, Decorated with Magnolia, Peony and Phoenix
Rock crystal (quartz)
19th century, Qing dynasty (1644–1911)
On loan from the collection of John and Maria Dirlam, E.109.05.5

This masterpiece was carved and polished to a glassy finish from a virtually flawless piece of rock crystal, a colorless variety of crystalline quartz. The Chinese call rock crystal *shuijing*, "water essence." They consider it a symbol of sacredness and perfection, with the ability to ward off evil and bring good luck. The deeply undercut decoration of the vase features a phoenix holding *lingzhi* fungus, peonies and magnolia as well as elephant-head ring handles. The wooden stand is decorated with plum blossoms and magpies.

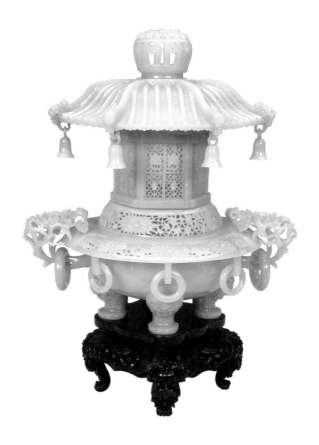

Pagoda Incense Burner
Pale green nephrite
Late 19th century, Qing dynasty (1644–1911)
On loan from the collection of John and Maria Dirlam, E.109.05.3

This jade incense burner exemplifies the imaginative eclecticism and supreme craftsmanship of skilled late 19th-century jade artisans. Structured in four separate parts, the censer includes the decorative motifs of six small and two large pendant rings; lion-dog legs; thin, translucent open-work of naturalistic chrysanthemum flowers and leaves; and a pagoda-style roof decorated with dragon heads holding six pendant bells. Pagodas, which originated in India, were built to commemorate acts of devotion or to house relics; the earliest Chinese pagodas were built during the third century.

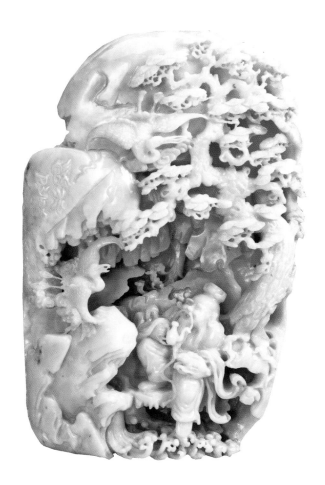

Boulder with Mountain Landscape and Taoist Sage
Lavender and pale green jadeite
20th century
Gift of John and Maria Dirlam, 1996.129

Holding both a vessel filled with the elixir of im-
mortality and a rabbit, which according to legend
pounds the herbs of the elixir, the sage observes the
arrival of two cranes. This lavender-tinted jadeite
boulder, depicting a scene from the Taoist mytho-
logical Penglai Islands (believed located off the east-
ern coast of China), exemplifies the virtuosity of 20th
century artisans using modern tools and abrasives.

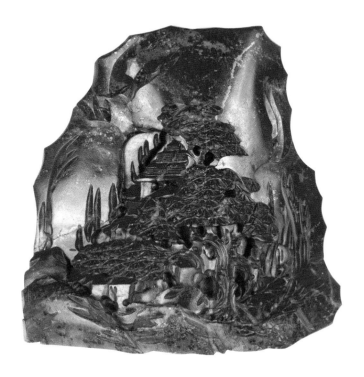

Small Boulder with Two Mountain Landscapes
Lapis lazuli
18th century, Qing dynasty (1644–1911)
Bequest of Mrs. Harry W. Goddard, in memory of Harry W. Goddard, 1938.63

Jade boulders and stones such as lapis lazuli evoked the "jewel-like" realms of Taoist immortals. They also embodied the pure, permanent essence and hues of the mountains and streams that Chinese landscape painters had long strived to capture. The landscape scene shown above is executed in higher relief than the one on the other side, suggesting that this side is the front.

Lapis lazuli is a rock composed mainly of lazurite but also of pyrite, calcite and other minerals. The brilliant blue lazurite gives the stone its color and small flecks of golden pyrite enhance its beauty. Lapis was imported from Afghanistan and Tibet as early as the Tang Dynasty (618–906).

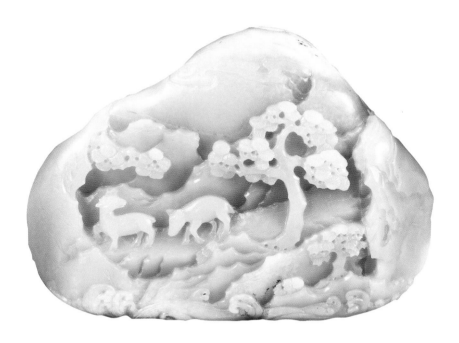

Boulder with Mountain Scenes: Two Deer on a Path
Pale green nephrite with white and russet area
Late 18th–early 19th century, Qing dynasty (1644–1911)
Gift of John and Maria Dirlam, 1997.137

One side of this nephrite boulder shows two deer on a mountain path. The lighter area on the top of the stone and the wispy clouds in low relief suggest a slightly hazy, moonlit night. The word *lu*, deer, is a homophone for the salary of a Chinese official (*lu*). The depiction of deer thereby became a favorite motif symbolizing wishes for successful scholarship, promotion and a good income. In Taoist lore the deer were uniquely capable of finding *lingzhi*, the mythical, sacred fungus believed to bestow immortality on any person or animal that consumed them.

On the reverse side, Shou Lao, the God of Longevity, recognized by his walking staff and high forehead, is depicted walking along a river toward a pavilion. He holds a peach of immortality, and his assistant holds a fungus of immortality.

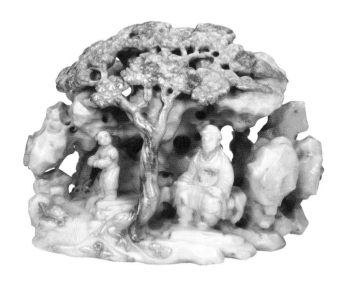

Small Boulder with a Hermit-Scholar in a Mountain Landscape
Tan and brown nephrite
Early 18th century, Qing dynasty (1644–1911)
Bequest of Mrs. Harry W. Goddard, in memory of Harry W. Goddard, 1938.58

The muted colors of this nephrite boulder give it an antiquarian feel. The dark discoloration of the crust of the boulder was used to depict the trunk and needles of a sheltering pine tree. The reclusive scholar, seated under the tree, has sent one of his assistants to the stream and another assistant, depicted on the reverse, to fetch his scrolls. Their animal companions are a tortoise and a crane (on the reverse), both symbols of longevity.

You ask me why I dwell in the green mountain;
I smile and make no reply for my heart is free of care.
As the peach blossoms flow down-stream and disappear into the unknown,
I have a world apart that is not among men.

<div align="right">Li Bai (699–762 CE)</div>

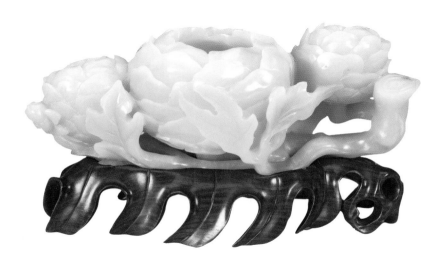

Triple Brush Washer in the Shape of Three Peonies
Pale green nephrite
Late 18th century, Qing dynasty (1644–1911)
Gift of John and Maria Dirlam, 2006.613

Blooming in late spring, the tree peony was considered the flower of the Chinese emperor as well as the "empress of flowers." Through these associations the peony also came to symbolize riches, good fortune, honor, affection and feminine beauty. This brush washer exemplifies the late 18th to early 19th-century imperial taste for naturalistic motifs, rendered in a realistic, sculptural style.

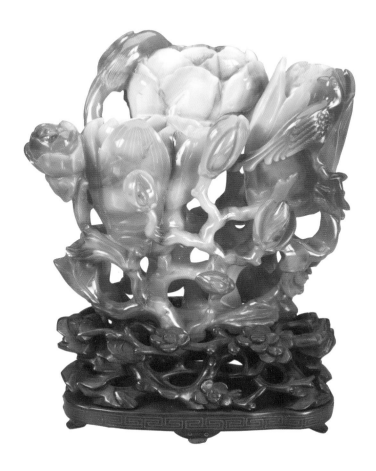

Triple Vase with Magnolia, Magpie, Peony and Phoenix
Russet carnelian
18th century, Qing dynasty (1644–1911)
Bequest of Mrs. Harry W. Goddard, in memory of Harry W. Goddard, 1938.59

Exquisite in color and artistry this carnelian vase features a magpie, a messenger of good news and the harbinger of spring. A phoenix, associated with summer or the empress, is depicted on the reverse. The magnolia and peony blossoms are both associated with feminine beauty. The motifs on the wooden base are plum, bamboo and *lingzhi* fungus.

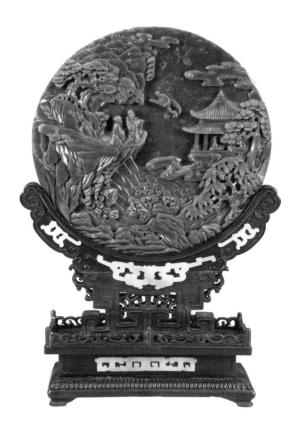

Circular Table Screen with Mountain Scene
Spinach-green nephrite
18th century, Qing dynasty (1644–1911)
Gift of John and Maria Dirlam, 1999.433

There was a great demand for sumptuous table screens during the reign of the Qianlong emperor (r. 1736–95). This round screen is a superb example of the skill and sophistication of the 18th-century jade artisans who catered to the imperial household and to wealthy officials and scholars.

Emulating round album-leaf paintings created by court painters, the scene reflects the aspiration of scholars for a life of elegant seclusion in the mountains. Two old men (immortals or scholar-hermits) are shown standing on a rocky mountain ledge, high above a raging river. One of them points to a vessel of elixir or wine on a table in a pavilion; a crane is depicted flying towards the pavilion with a message in its mouth.

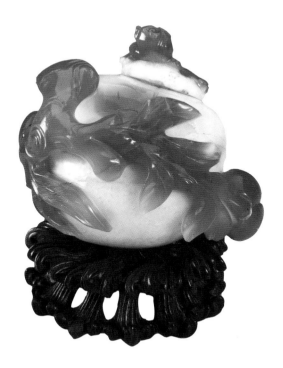

Water Container in the Shape of a Ripe Peach
White, pink and russet carnelian
18th century, Qing dynasty (1644–1911)
Bequest of Mrs. Harry W. Goddard, in memory of Harry W. Goddard, 1938.12

The artisans who worked on this carnelian container took great care in using the colors of the stone to suggest a velvety, pinkish-white peach enveloped by a russet branch with ripening fruits. The lid is surmounted by a *qi*-dragon. This container is symbolic of one of the peaches of immortality grown by the Taoist Queen Mother of the West, Xi Wangmu. According to legend the peach trees in the queen's garden bloomed once every 3,000 years; their fruit then took another 3,000 years to ripen.

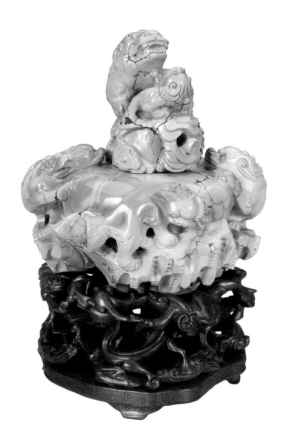

Water Container Decorated with Lion-Dogs
Turquoise
18th century, Qing dynasty (1644–1911)
Bequest of Mrs. Harry W. Goddard, in memory of Harry W. Goddard, 1938.37

Functional objects on the scholar's desk also served as objects of contemplation and discussion. This turquoise container is shaped like a boulder, with playful Buddhist lion-dogs (*shi*) symbolizing valor and energy. The lion-dog, posing on the lid with a paw on its cub, refers to a rebus (pictorial riddle) conveying the wish that "the son may follow in his father's footsteps and rise to the status of a high-ranking official" (*tai shi shao shi*). Turquoise was a favored material during the reign of the Qianlong Emperor (1736–95).

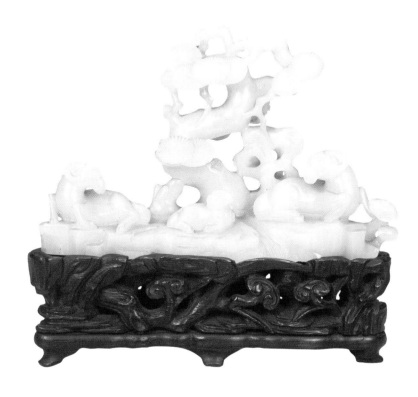

Horned Sheep Resting near a Stream and a Pine Tree
White nephrite
17th century, Late Ming (1368–1644) or early Qing dynasty (1644–1911)
Bequest of Mrs. Harry W. Goddard, in memory of Harry W. Goddard, 1938.57

Two adult sheep turn to look at their offspring, all three resting under a pine tree near a stream and the fungus of immortality (*lingzhi*). The word for sheep or rams (*yang*) is a homophone for the Taoist male principle (*yang*) and for the unbroken lines (*yang*) used in the fortune-telling trigrams and hexagrams discussed in *The Book of Changes* (*Yi Jing* or *I Ching*). Referring to the trigram of three long lines (symbolizing the three months of spring), the depiction of three sheep represents wishes for a new and prosperous start in spring. The wooden base is carved to look like branches and *lingzhi* fungus.

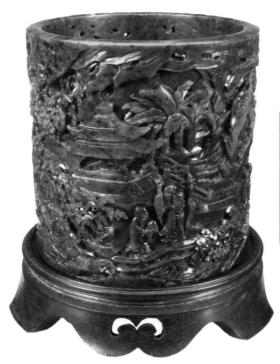

Brush Holder with a Scene of Sages in a Mountain Landscape
Spinach-green nephrite
18th century, Qing dynasty (1644–1911)
Gift of John and Maria Dirlam, 1996.130

Brush holders were used to store rolls of paper, scrolls, brushes and *ruyi*-scepters. This jade pot was conceived to resemble the cylindrical shape and detailed ornamentation of traditional bamboo and lacquer brush holders. Made of Siberian spinach-green jade, the surface is decorated with a forested mountain landscape scene. Three immortals stand near a pavilion; two of them lean on staffs and one holds a peach of immortality. A fourth sage and his young assistant are gathering *lingzhi* (fungus of immortality), the latter figure seated near a stream. Two cranes are depicted on the other side of the pot, one flying and the other resting near a pavilion.

Naturalistic scenes such as this were popular in 18th-century paintings and ceramics. Notable compositions were reproduced in woodblock prints and stone engravings, which then often served as models for various artisans. Jade artisans often re-created the designs in differing planes of relief. Sometimes, as is the case here, they also pierced the walls of the vessel.

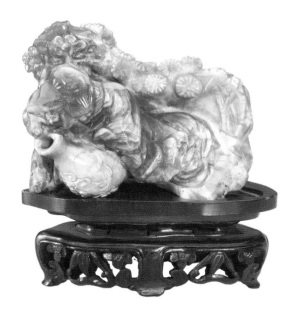

Water Dropper: Poet Li Bai Sleeping Near Pine, Plum and Bamboo
Aqua, mauve and white fluorite
18th century, Qing dynasty (1644–1911)
Bequest of Mrs. Harry W. Goddard, in memory of Harry W. Goddard, 1938.60

Used to add water during the grinding of calligraphic ink, this water dropper depicts the Tang dynasty poet Li Bai (also Li Po or Li Tai Bai; 699–762). The poet leans against a wine vessel, asleep next to pine, plum blossoms and bamboo, the "Three Friends of Winter." Li Bai spent much of his life drinking wine, wandering and letting time pass. He was however deeply interested in Taoism, and his verses showed great sensitivity to the beauty of nature and human emotions. One of Li Bai's most famous poems reads:

Amidst the flowers a jug of wine
I pour alone lacking companionship,
So raising the cup I invite the moon,
Then turn to my shadow which makes three of us.
Because the moon does not know how to drink
My shadow merely follows my body.
The moon has brought the shadow to keep me company a while,
The practice of mirth should keep pace with spring.
I start a song and the moon begins to reel,
I rise and dance and the shadow moves grotesquely.
While I'm still conscious let's rejoice with one another,
After I'm drunk let each one go his way.
Let us bind ourselves for ever for passionless journeyings.
Let us swear to meet again far in the Milky Way.

Translation by William Acker, 1967

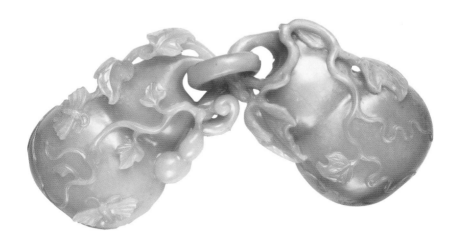

Box in the Shape of a Double-Gourd
Pale green nephrite
18th century, Qing dynasty (1644–1911)
Gift of John and Maria Dirlam, 1997.136

This box is shaped like a double-gourd with a smaller gourd to one side; it is also constructed as two interlocking halves. Double-gourds represent the unity of heaven and earth: the upper half signifies Heaven while the lower part symbolizes Earth. Immortals and Taoist sages are often shown using dried gourds, shaped into containers, to hold magical elixirs. Through its popular use, the gourd also became known as a medicinal charm for longevity and protection against evil.

Butterflies (*die*) signify joy and romantic marital bliss. Since the Chinese word for butterfly is a homophone for "repeat" (*die*), two butterflies multiply the wish for a happy marriage. The stem with trailing tendrils predicts the continuation of the family for "ten thousand generations" (*wan dai*; lit. "vine stem").

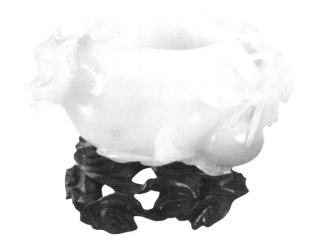

Water Container in the Shape of Pomegranates with a Cicada
Whitish nephrite with some russet staining
18th century, Qing dynasty (1644–1911)
Bequest of Mrs. Harry W. Goddard, in memory of Harry W. Goddard, 1938.50

This water container for moistening brushes is shaped like a pomegranate (*shi liu*) and suggests a rebus or pictorial puzzle signifying joy (*shi liu kai xiao kou*: "the open pomegranate opens its mouth in laughter"). According to Taoists, the pomegranate was an essential ingredient for creating the elixir of immortality. Due to its many seeds it was also considered a fruit of abundance and fertility. The cicada, which emerges out of the earth as a pupa to discard its shell-covering, is an emblem of eternal life.

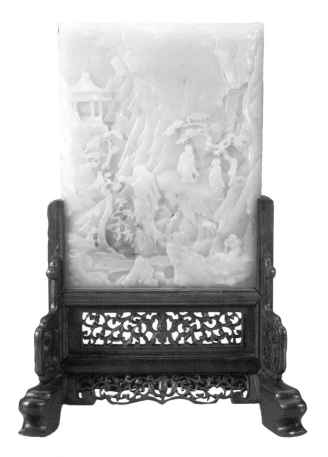

Table Screen with Mountain Landscapes
Pale green nephrite
Mid-18th century, Qing dynasty (1644–1911)
Gift of John and Maria Dirlam, 1996.131

Screens helped the scholar focus on his calligraphy and protected the unrolled work from ink splashes. Inspired by visions of the lofty realms of Taoist immortals, this screen of translucent nephrite is decorated on both sides with scenes of scholars and assistants living in the mountains, climbing towards mountain pavilions. Production of jades as elegant desk accessories reached a peak during the 18th century, when Manchu emperors, members of the court and wealthy merchants sought to emulate scholars in taste and cultivated artistic pursuits.

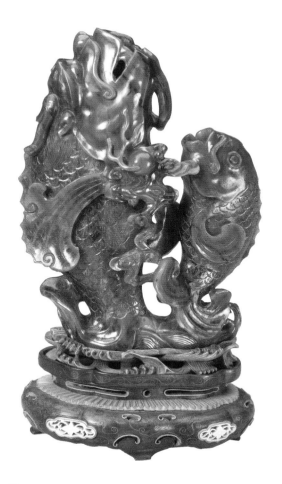

Double Carp Vase
Spinach-green nephrite
Mid-18th century, Qing dynasty (1644–1911)
Bequest of Mrs. Harry W. Goddard, in memory of Harry W. Goddard, 1938.69

Ideal as a gift for a scholar's desk, this vase expresses a wish for literary success and official promotion. It is shaped like two carp leaping from swirling waves, the larger carp being transformed into a dragon with whiskers, bulging eyes and horns. According to legend, carp that succeeded in swimming upstream in the Yellow River and passed the Long-men (Dragon Gate) rapids, turned into dragons. The carp's feats of vigor and perseverance were compared to scholars who spent years studying for rigorous examinations in order to join the Confucian bureaucracy and gain a life of privilege. The imperial quality of this work is evident in its fine details. This is also true of the stand, with its carved waves and inlaid ivory and silver wire.

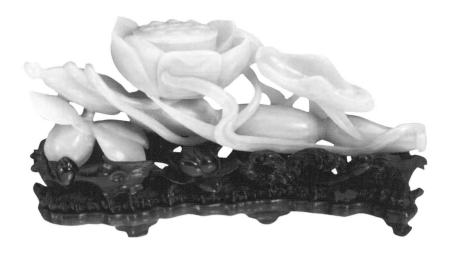

Brush Washer in the Shape of Lotus Flowers, Seedpod and Leaves
Pale green nephrite
Early 18th century, Qing dynasty (1644–1911)
Gift of John and Maria Dirlam, 2007.238

The lotus (*lian-hua* or *he hua*) is one of the Eight Treasures of Buddhism. Since the flowers of the lotus bloom as its seeds ripen, it symbolizes the truth preached by Buddha that immediately bears fruits of enlightenment. Emerging out of the mud, white, sweet-smelling, inwardly empty and outwardly upright, lotus flowers are also emblematic of pure and faithful spirits.

By the Song dynasty the lotus also had become associated with virtuous Confucian gentlemen. Many lotus-shaped vessels were made for courtiers and scholars during the Ming and Qing dynasties. This brush washer includes a hollow, lidded lotus seedpod (*lian zi*), implying wishes for many upstanding, truth-seeking sons (*zi*). The wooden base is carved to depict lotus flowers and buds amidst waves and water grasses.

MEASUREMENTS OF JADES*

1938.12	7.0 x 8.0 cm	1996.130	16.0 x 15.0 cm
1938.27	9.5 x 11.0 cm	1996.131	23.0 x 17.0 x 1.0 cm
1938.30	17.8 x 9.5 cm	1997.136	5.0 x 13.5 cm
1938.34	14.5 x 15.5 cm	1997.137	16.0 x 23.2 cm
1938.37	20.0 x 10.0 cm	1999.433	20.3 x 1.3 cm
1938.40	12.0 x 7.6 cm	1999.440	32.5 cm x 9.0 cm
1938.48	11.7 x 9.6 cm	2001.454.1	30.2 x 14.4 cm
1938.50	3.8 x 8.0 cm	2001.454.2	30.2 x 14.4 cm
1938.52	10.2 x 10.0 cm	2002.550.1	30.3 x 14.5cm
1938.57	8.0 x 11.2 cm	2002.550.2	30.3 x 14.5cm
1938.58	9.5 12.3 cm	2006.611	9.0 x 15.2 cm
1938.59	15.0 x 14.0 cm	2006.612.1	17.0 x 25.0 cm
1938.60	9.0 x 11.5 cm	2006.612.2	16.6 x 27.7 cm
1938.62	5.5 x 11.0 cm.	2006.613	8.0 x 21.0 cm
1938.63	9.9 x 9.5 cm	2007.238	9.0 x 25.0 cm
1938.64	12.0 x 16.3 cm	2007.239	10.5 x 17.0 cm
1938.66	20.5 x 14.0 cm	2007.240	15.4 x 7.5 cm
1938.67	17.0 x 17.2 cm	2008.120	10.0 x 32.0 cm
1938.68	6.5 x 17.5 cm.	2008.121	22.8 x 10.3
1938.69	17.0 x 13.0 cm	2008.122	26.0 x 18.3 cm
1938.70	15.5 x 7.5 cm	2009.153	8.0 x 18.5 cm
1938.71	14.7 x 5.0 cm	E.109.05.3	26.0 x 17.0 cm
1996.129	31.5 x 23.0 x 7.6 cm	E.109.05.5	23.5 x 19.0 cm

Measurements are given with height, width and depth.

CHINESE CERAMICS

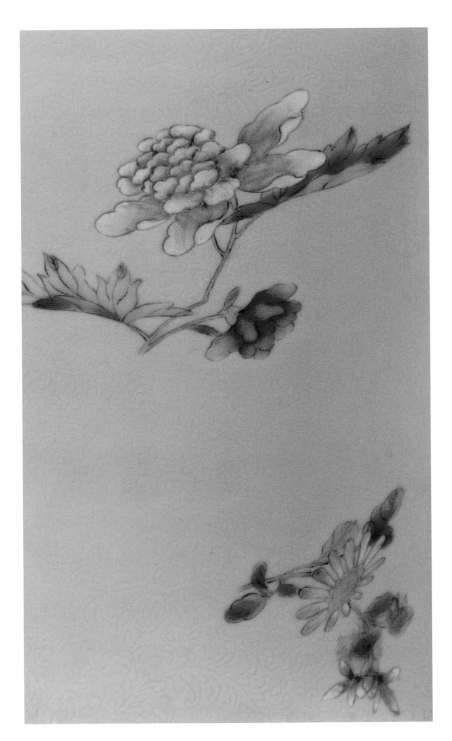

Spanning over 8000 years, the history of Chinese ceramics is rich in its blend of respectful adherence to ancient traditions and stunning technical and ornamental innovations. Connoisseurs praise Chinese ceramics for their timeless beauty and appreciate how they embody the efforts of generations of Chinese potters to perfect classic wares as well as invent fashionable new wares. Embellished with a great variety of glazes and décor, ceramics were made for daily utilitarian or decorative use at the imperial court as well as in the homes of the bourgeoisie; some were also made for ritual use.

The ceramics exhibited in the Chinese Decorative Arts Gallery of The Worcester Art Museum include earthenware, stoneware, porcelaneous ware and porcelains that range in date from the Tang dynasty (618–906) through the Qing dynasty (1644–1911). Included are examples of classic Song dynasty (960–1279) wares, such as, Ding, Cizhou, Yaozhou and Jun wares produced in northern China, as well as Longquan and Jingdezhen wares produced in southern China. The Museum's Jingdezhen porcelains, dating from the 12th through the 19th centuries, include blue-and-white and monochrome wares, as well as porcelains with polychrome overglaze enamel decoration. The Neolithic as well as Shang and Han dynasties tomb earthenware vessels and sculptures, jades and bronzes will be on view in the neighboring gallery in the near future.

The Museum's collection of Chinese ceramics owes much to the generosity of local collectors. One of the first donations was an early 19th-century covered tea bowl with a goldfish design that came to the Museum in 1903 from the collection of Helen Bigelow Merriman. Mrs. Merriman also helped fund the acquisition of the splendid Ming dynasty *fahua* ware wine jar with a design of the "Eight Taoist Immortals" and "Eight Buddhist Symbols." Mrs. Merriman was the wife of the Reverend Daniel Merriman, the first president of the Museum's Board of Trustees and a member of the Collections Committee. A more recent gift is the exquisite pair of early 18th-century bowls with garden flower designs donated by Mr. and Mrs. Eugene Bernat of Mendon, MA, who also gave the Museum a number of Tang dynasty tomb sculptures.

Among the most interesting gifts are some Tang and Song dynasty vessels that came to the Museum from two friends of James Marshall Plumer, an American scholar, Chinese customs official, and later a professor at the University of Michigan, who excavated Chinese kilns. Henry Jewett Green of Petersham, MA,

presented the Museum with a Tang dynasty splashed blackware jar that had been a gift from Plumer, and Mable Gage of Worcester donated a pair of Song dynasty Jian ware tea bowls that came from a kiln in Fujian province where she and Plumer had done excavations in 1935.

Other ceramics were purchased by the Museum from important private collections such as those of the banker J. P. Morgan of New York City and Emile F. Williams, a Boston dealer. The largest collection represented is that of John Chandler Bancroft who died in 1901 and left his famous collection of Japanese prints to the Worcester Art Museum. His collection of Chinese and Japanese ceramics was on loan to the Museum from 1904 until it was purchased in 1954 from the estate of his son. Curators have continued to strengthen the collection with strategic purchases.

Clays

The Chinese use the term *ci* to refer to stoneware, porcelaneous ware and porcelains. In other words, the Chinese only distinguish between *tao*, low-fired ceramics such as porous, non-vitrified earthenware, and *ci*, high-fired ceramics that are resonant, dense and impervious to liquids. In the West, stoneware and porcelaneous ware are terms used to indicate high-fired ceramics that, relative to true porcelain, are coarser and fired at slightly lower temperatures. Porcelain is made with white, vitrified clay that is nearly free of trace impurities and fired to the highest temperatures, usually between 1250° and 1350°C.

China is divided geographically and geologically by the Yangtze River into North China and South China. The clays vary in composition and purity from one province to the other and over time even at certain porcelain kiln centers. Generally speaking, the porcelains made in northern China were dependent on clay called kaolin (*gaoling*), also known as "China clay." Kaolinite, the chief constituent of kaolin, is formed from the weathering of feldspar, an aluminous silicate that had been liberated overtime from decomposing granite (a hard igneous rock consisting mainly of quartz, mica and feldspar). Kaolinite, mined, highly refined and pulverized, formed soft, white and moderately plastic clay that could be used for the creation of dense and compact bodies.

The clays of southern China were mainly made of petuntse or *baidunzi* (also known as "China stone" or porcelain stone, *cishi*). Derived from partly decomposed granite, petuntse was crushed, levigated and dried. As was the case with kaolin, petuntse was shaped into small bricks before being distributed to the

kilns. Porcelain stone is slightly different in its composition of minerals than kaolin: it retains a high degree of unaltered feldspar, quartz (composed of silica) and fine-grained potassium mica (sericite); a small amount of kaolinite is sometimes also present. Highly siliceous, the petuntse clays of southern China made ceramic bodies of a glassy, sugary texture. The petuntse mined near the Dehua kilns of Fujian province, for example, was used to make clay with the consistency of pastry dough, ideal for making small, molded vessels and figurines with applied decoration.

At Jingdezhen in Jiangxi province, southern China, local petuntse began to be combined with small amounts of kaolin to make porcelains in the late 13th or early 14th century. Such kaolinized porcelain clay became increasingly important from the mid-17th century onwards as Jingdezhen potters strove to compose more plastic and "workable" clay mixtures that could reliably be fired within an increased range of temperatures. The alumina-rich kaolin component added whiteness and brightness and allowed the shape of the porcelain bodies to be retained during firing at high temperatures. The silica-rich porcelain stone component added translucency and fusibility.

When the Chinese emperor made Jingdezhen the center for an imperial kiln complex in 1683, these fine and flexible porcelain clay recipes enabled the production of large quantities of elegant vessels with varied glazes for use at the imperial court. By the early 18th century, a half petuntse and half kaolin clay mixture had become the norm. Porcelains made of this clay composition were placed in the hottest parts of the large single-chambered Jingdezhen kilns.

Glazes

Most Chinese ceramics were covered with hard, glass-like glazes that served both to seal and decorate the clay bodies. Glazes could be opaque or transparent, lightly or brightly colored, glossy or matte. A glaze was usually applied to an unfired clay body and fired once. Integration was possible in one firing because the body and glaze were usually made of similar raw materials, with similar rates of contraction and expansion during firing. The glaze did, however, also need a flux, a component to lower the melting point of silica. When reacting with silica, the flux enabled the body material and the glaze to melt, fuse, and vitrify at a reasonable temperature.

Some Chinese ceramic wares required a second firing. This was especially the case with unglazed bodies that needed to be pre-fired, that is, strengthened through a "biscuit firing" before being glazed (often with lead glazes) and then re-fired at a lower temperature. The "glaze-fit" of such biscuit-fired vessels was

usually not as good as on raw-glazed wares. Glazed, high-fired porcelains, embellished with overglaze enamel painting or glazes, also needed a second lower-temperature firing.

The primary Chinese glazes, namely lead, lime, lime-alkali, and porcelain glazes, are classified according to the flux included. Lead glazes, containing lead flux, were typically applied to earthenware or pre-fired stoneware or porcelain bodies that were then given a low-temperature firing. On the other hand, lime and lime-alkali glazes were applied to unfired stoneware or porcelain bodies that were then fired once at a high-temperature. The characteristically "thin and frosty" lime or ash glazes have high amounts of calcia and lime for their flux, added in the form of wood ash. Lime-alkali glazes are rich in lime and potassia (an alkali) fluxes and can melt at lower temperatures than lime glazes. To a lesser extent alkali-lead glazes were also used in Chinese ceramics, for example on *fahua* ware.

Porcelain glazes include a high proportion of petuntse, which is an acid rock. Developed, improved and perfected in southern China, such porcelain glazes include the fluid *qingbai* glaze that is rich in lime (glaze ash) flux. Tiny amounts of dissolved iron in the *qingbai* glaze render it a pale watery blue. By the middle to late 14th century, a new, colorless transparent lime-alkali glaze enabled the development of blue-and-white ware at Jingdezhen. The new glaze could both cover and preserve the definition of the painted cobalt decoration. In the late 18th and 19th centuries a white porcelain glaze was sometimes used for ware with overglaze enamel decoration. The opaqueness of this white glaze is due to the fact that all the silica in the glaze did not melt when the porcelain body was fired to maturing temperature.

A small number of Chinese glazes do not fit precisely into any of the above-mentioned categories. The Ding ware glaze, for example, is low in calcium, alkalis and titanium and rich in silicon, aluminum and magnesium—the latter ingredient being its major flux. Also notable are the technically sophisticated Jun, Jian and copper-red monochrome glazes that are variations of lime-alkali glazes but with a chemistry that encourages "liquid-liquid" phase separation during cooling, giving rise to colors and textures not achieved by ordinary means.

The coloring agents used in nearly all Chinese glazes until modern times were the oxides of iron, copper, cobalt and manganese. Iron could produce a very wide range of warm and cool colors in both oxidizing and reducing kiln atmospheres, including shades of red, brown, rust, amber, yellow, black, green and blue. Trace elements in the raw materials, such as titanium, could greatly

modify the color of iron-tinted glazes. Lower titanium-to-iron ratio glazes, fired in reduction, gave rise to bluer tones; glazes with the opposite ratio gave rise to greener tones. Green copper glazes were either lead-fluxed glazes or porcelain glazes fired in oxidation. Red copper porcelain glazes, created in reduction firing, were striking but extremely difficult to control. Turquoise alkali-lead glazes, low-fired in oxidation, were also tinted with copper.

Different monochrome porcelain and enamel glazes were perfected and invented in order to embellish imperial porcelains especially during the Ming (1368-1644) and Qing (1644-1911) dynasties. This development was at first partly spurred by Emperor Hongwu (1368-98), who in 1369 decreed that the porcelains used during ceremonies on the imperial altars dedicated to the Sun, Moon, Heaven and Imperial Ancestors, and the Earth, had to have mono-chrome glazes of the correct auspicious colors: red (reduced copper red) for the Sun; white (transparent porcelain glaze) for the Moon; blue (high-fired cobalt blue) for Heaven and Imperial Ancestors; and yellow (low-fired yellow enamel) for the Earth. Some of the most popular colors of Qing dynasty glazes were turquoise, brown, mirror-black, iron-red, coral, peach-bloom, lime green, dark purple, and variations of Song celadon glazes.

Decorative Techniques

Ceramics can be handmade, thrown on a potter's wheel, or molded. Using the wheel was the most common method of producing ceramics of various shapes. Very large vessels were often thrown in a few large sections. The edges of these parts were fused by scoring, joining, wetting and smoothing the surfaces. The Museum's large blue-and-white Ming vase (see 1959.6), for example, was made by joining two large bowl shapes at the rims and then adding the neck. Vessels with impressed decoration were first thrown on a wheel and then placed over a fired ceramic mold and beaten with a paddle.

Dried but still unfired clay vessels were often adorned with painted, carved, molded or low relief (i.e., slip lines or appliqué) decoration. Once decorated, vessels were glazed and fired. Mineral pigments, such as the expensive cobalt used for blue underglaze painting, were usually mixed with water. Liquefied clays, or slips, could help camouflage or brighten bodies of inferior or dark clay. They could also be used to add slip-marbling or slip-carving designs. The "cut-glaze" or *sgraffito* ("scratched") décor on Cizhou ware, for example, required carving through the outer coating of slip to reveal the differing color of an underlying slip.

Ding, Yaozhou, and *qingbai* wares exemplify the use of incised and carved patterns as well as the more time-efficient use of molds to impress designs. Reminiscent of cloisonné metalwork, the motifs on *fahua* ware were outlined with slip-lines. After firing, the cells created by the slip-lines were filled with glazes. These glazes were then fixed by means of a second lower-temperature firing.

Especially during the Qing dynasty, many porcelain vessels were decorated with overglaze enamel painting. Enamels are essentially powdered glass colored with metallic oxides and mixed with varied media (e.g., oil, liquid gum, or plain water). Enamels allowed for detailed designs in vibrant colors, the two most notable palettes of which were the transparent *famille verte* ("green family") enamels and the opaque *famille rose* ("pink family") enamels. Enamels were usually applied onto clear-glazed and high-fired porcelain bodies, but they could also be painted onto high-fired, unglazed (biscuit) porcelain bodies. The porcelain bodies were re-fired in a special low-firing kiln in order for the enamels to melt and bond with the underlying material. During the Ming and Qing dynasties a number of porcelains were embellished with both underglaze and overglaze painting in the so-called *doucai* or *wucai* styles.

A small number of "in-glaze" techniques defy categorization, including paper-cut, leaf, resist, and "splashed" decoration. In the Museum's collection splashed decoration is represented by the Tang dynasty blackware jar and Song dynasty Jun ware dish. The jar is embellished with bluish-white wood-ash-glaze splashes, and the dish with a purple-red copper solution splash. These markings were freely brushed onto unfired base glaze which, when fired, caused the splashes to change color.

Drying

Water is added to powdered rock to produce workable clay that enables the potter to shape a clay body. In order for the clay body to become "ceramic" it must first be dried to "leather hardness" in a location with an even, warm temperature. A carefully monitored drying process is important since the clay bodies are susceptible to shrinking and cracking when dried too fast. This is especially the case with bodies made of fine particle clays that hold more water. These bodies tend to shrink more as they dry than those made of coarser clays that hold less water. If clay vessels are not dry enough, they can burst during the firing process as too much steam and pressure are built up.

Dried clay bodies ready for firing were usually placed within protective "saggars," refractory ceramic boxes that shielded the pots from flames and ash in the kilns and kept them from warping. Within the saggars, the ceramics were supported on top of clay rings or discs, which in turn often rested on beds of sand. To raise a dish or vessel with a glazed base off the bottom of a saggar, a crown-like clay ring with small spikes was often used. These spiked clay rings left small sesame-seed shaped marks known as spur-marks.

Clay bodies could also be fired on their feet or on their rims. The thinly potted Ding and *qingbai* ware bowls, endowed with small feet, were stacked in stepped saggars and fired upside down, the rims being left unglazed. After their "upside-down" (*fushao*) firing and cooling, the unglazed rims were often disguised and embellished with metal bands.

Kilns

The kilns used in North and South China were different in construction. The favorite northern kiln was the small *mantouyao* ("bun kiln"), which had a domed, well-insulated firing chamber located between a fire box and a chimney. This kiln had an efficient cross-draught but required a long time to heat up with wood or coal for fuel, as well as a long time to cool down. The *longyao* ("dragon kiln") used in southern China was built to snake up the side of a hill and was often divided into several firing chambers for different wares. With a fire box fueled by wood at the lower end and many holes along its sides, the *longyao* could quickly reach high temperatures; conversely it also cooled very rapidly. The need for continual stoking and the rapid cooling often resulted in inconsistent production quality.

Beginning at the end of the 16th century the potters at Jingdezhen in southern China began to use the highly efficient *zhenyao*. This kiln has a single, large and well-insulated "egg-shaped" chamber, with a fire box at the tall and wide-domed front end and a very tall, tapering chimney at the lower, narrower back end. The strong draught facilitated by the chimney allowed the kiln to heat quickly to very high temperatures, finely adjusted through vent-holes. A single firing often only lasted from between 24 to 36 hours from start to finish. Utilizing the natural decrease in heat from the fire box to the chimney, a wide range of wares could be fired simultaneously. The clay bodies richest in kaolin and covered with glazes lowest in glaze ash were fired nearest the hot fire box. Lower-firing bodies that were high in petuntse and covered with glazes rich in glaze ash were placed in the cooler parts, closer to the chimney.

The very coolest parts of the kiln were reserved for saggars with wares that needed pre-firing, as well as for high-fired whitewares and unglazed biscuit bodies that needed to be re-fired with lead oxide or potassia-fluxed glazes. Air holes in the walls ensured that these wares did not overfire, and they also allowed for the use of oxidizing glazes within the *zhenyao* atmosphere that was generally reducing.

Reducing and Oxidizing Kiln Atmospheres

Ceramics may be fired in reducing or oxidizing conditions, and these atmospheric conditions affect the color of the clay bodies and glazes. An oxidizing atmosphere is achieved by letting in as much air as possible through the vents and into the firing chamber. Such a "clean," high-oxygen firing tends to develop glazes with warmer, brighter tones. An oxidizing atmosphere is also essential for the production of certain colors such as turquoise.

A reducing atmosphere is created by closing most of the vents of the kiln, thereby producing a smoky fire with reducing gases such as hydrogen and carbon monoxide. Starved of oxygen, the kiln fire begins to pull oxygen molecules from the pots, changing the chemistry of clay and glazes. Such a low-oxygen, smoky atmosphere tends to create glazes with cooler tones, often with a slight bluish or grayish tinge. A reducing atmosphere is also essential for the firing of colors such as copper red. As exemplified by some Longquan wares embellished with both a cool-toned celadon glaze and warm-toned reddish biscuit areas, striking effects can be created when wares are fired in reduction and cooled in oxidation.

Firing

To fire the clay vessels, the temperature inside the kiln is gradually raised until the desired peak temperature is reached. The firing process goes through several stages. In the first stage (about 120°C) the "pore water" locked inside the pores of dried clay is removed as steam. In the following stage (120–350°C) any absorbed water ("interlayer water") is eliminated and organic matter in the clay begins to decompose. The ceramic change occurs at about 350–650°C when the "bound" or chemically combined water evaporates and kaolinite begins to be converted into the crystal "metakaolin." In the next stage (650–950°C) carbon is burned out and clay particles are "sintered," that is, bonded and partly fused.

The process of vitrification begins from 950°C to 1100°C when the metakaolin breaks down to form "spinel" (a hard glassy mineral) and releases free silica. The free silica melts and forms glass that permanently glues the clay particles together. The temperature must be raised even higher in order to form strong, glassy porcelain. At the peak firing stage (up to about 1350°C), interlocking needle-like aluminum silicate crystals, known as mullite, are formed. Even more silica is thereby also released and melted, providing more glass in the ceramic body. In reaching this maturation stage, the high temperature is sometimes maintained for a period known as "soaking." The kiln is then cooled to begin a process in which the ceramic bodies contract and the glass formed in the body solidifies.

KEY TO KILN LOCATIONS IN CHINA

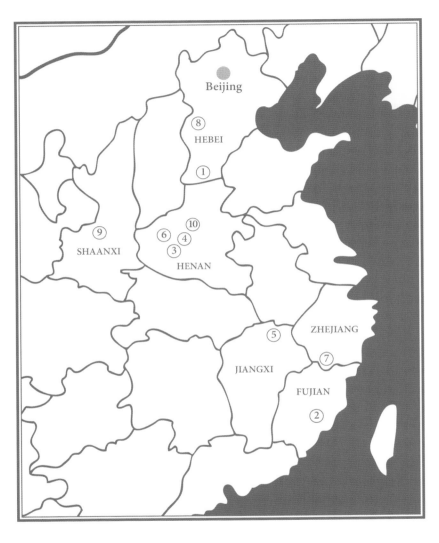

Cizhou	1	Jingdezhen		Quyang	5	8
Dehua	2	Linru		Yaozhou	6	9
Duandian	3	Longquan		Yu	7	10
Huangdao	4					

EARLY CHINESE CERAMICS

Pottery, like the crafting of jades, has been of enormous importance in the culture and history of China. Fine natural clays, along with highly organized workshops with skilled craftsmen, have sustained a universally acclaimed ceramic tradition that began with earthenware pots (from about 7000–6000 BCE) and continues into the present with porcelain production at Jingdezhen in Jiangxi province in South China.

High-fired pale stoneware was developed through experimentation with increasingly pure and refined clays. While "near-porcelain" vessels were produced in the late 6th century, high-fired white porcelains were first developed at kiln sites in North China from the mid-8th century onwards. As China enjoyed periods of great economic, political and cultural growth from the 7th to the first half of the 17th centuries, different vessel shapes, glazes, and decorative techniques were developed to satisfy the imperial court, and for exportation to satisfy foreign demand. Works in the Museum's permanent collection, representative of several major ceramic wares from this early period, are on exhibit in the smaller wall case. The unique characteristics of these comparatively small and elegant works, appreciated by connoisseurs, are mentioned in the following object descriptions.

Box-shaped Pillow with Floral Design
First half of the 8th century, Tang dynasty (618–906)
North China, Shaanxi-Henan provinces
Sancai ware
Earthenware covered with white slip and *sancai* ("three-color") lead glazes
Museum Purchase, 1954.50

Expressively decorated lead-glazed ware was fully developed in the Shaanxi and Henan provinces during the reign of the notorious Empress Wu (r. 690–704 A.D.). The term *sancai* ("three-color"), which is often used for this lead-glazed ware, was coined when China's East-West Longhai railway was being built in the early 20th century. It was then that funerary goods, including many press-molded horses, camels and figures in amber, green and white were excavated from tombs.

Since lead glazes are poisonous, *sancai* ware was widely used as burial goods or as exotic wares for utilitarian purposes other than for holding food or drink. Scholars believe that ceramic pillows, such as this example, may have been used as a display stand or as an armrest by a Tang dynasty doctor when taking a patient's pulse. Lead-glazed ware remained popular in China and was widely exported until the collapse of the Tang dynasty, a time when the elaborate burials of the ruling class came to an end.

Sancai earthenware (and sometimes stoneware pre-fired about 1150ºC) were first covered with a white-clay slip. White areas were reserved by applying a clear lead glaze or by using a wax-resist technique. The colored lead glazes, brushed or dabbed on, were tinted with mineral oxides: iron for brownish-black, brown, amber and yellow, and copper for the "cucumber-rind" green. Introduced in the second half of the 7th century, cobalt was used to create dark blue, especially in Gongxian, Henan province.

Sancai earthenware and stoneware goods were fired in oxidation in small, round, wood-burning *mantouyao* or "bun-kilns." In spite of their low temperature firing (about 900–1000ºC), the lead glazes tended to run, especially on vertical surfaces.

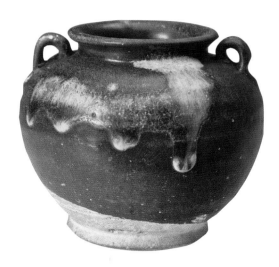

Jar with Applied Handles and Bluish-White Splashes
8th or 9th century, Tang dynasty (618–906)
North China, Henan province
Northern "splashed" blackware
Stoneware with iron-rich, high-lime glaze and phosphatic suffusions
Gift of Henry Jewett Green, 1953.82

During the Tang dynasty, high-quality, utilitarian stoneware was sturdy in form and austere in color. The vessels were provided, inside and out, with dark matte glazes tinted with iron. Kilns producing such "blackware" in Henan province, especially at Huangdao (Jia county) and Duandian (Lushan county), also became known for their dramatic variant known as "splashed" blackware.

This ovoid jar was first dipped in an iron-rich, brownish-black glaze. Its glazing was deliberately stopped well above the foot so that the glaze would not run off and fuse the foot to the kiln furniture. The "splashes" were added by dripping, pouring or brushing a wood ash-rich mixture onto the raw dark glaze before firing. During the high-temperature firing (at about 1270–1300ºC in an oxidizing to neutral atmosphere) and slow cooling, the ash-slag splashes turned into bluish-white suffusions (*yuebaiban*). This splashed inglaze decoration may have inspired the later development of splashed Jun wares in Henan province (see 2008.47).

Stem Cup
9th or early 10th century, Tang dynasty (618–906) or Northern Song
dynasty (960–1127)
North China, Hebei province
Northern whiteware
Porcelain with transparent kaolin-rich glaze
Museum purchase, 1954.51

Now generally recognized as the world's earliest porcelain, Xing and Ding white-ware originated in Hebei province, where both pale stoneware and white-firing secondary kaolin clays were readily available. Bright and glossy, the white-fired Xing and Ding wares were appreciated as practical, inexpensive substitutes for precious metals and stones and for their aesthetic appeal. Tang dynasty connoisseurs described the spirit and appearance of the early Xing porcelain wares, as "bright as silver, white as snow," and as resembling white jade.

The strong influence of Xing ware on Ding ware during the Tang dynasty makes it very difficult to differentiate between early examples of these two whitewares. Their raw materials and simple shapes were similar. Furthermore, they were both fired using wood at high temperatures (as high as 1350°C) and in a reducing atmosphere. The low-shrinking, kaolin-rich clays of the bodies caused the surfaces to be finely crazed. Crazing—the result of the glaze shrinking more than the body during cooling—was slightly less prominent on Ding ware since its thin glaze was richer in the low-contracting silicon, aluminum, and magnesium oxides.

Popular with the imperial court as well as with the general population, Xing and Ding whitewares were traded throughout Asia, the Middle East and Northern Africa, an export that continued until the end of the 11th century. This finely potted and minutely crazed stem cup, created either at a Xing or early Ding ware kiln, was valued as a rare treasure. The nicks on its rim and foot were repaired with gold lacquer, the traditional way of restoring highly prized ceramics in Japan.

Bowl with Design of Ducks, Water, Ripples and Water Plants
11th or 12th century, Northern Song dynasty (960–1127)
North China, Hebei province
Northern whiteware: Ding ware
Porcelain with incised design under a transparent, kaolin-rich glaze;
unglazed rim covered with band of copper alloy
Museum purchase, 1954.49

From the 10th century onward, Ding whiteware surpassed Xing whiteware in both refinement and scale of production. Relying on the fine, stable clays found in Quyang county (Hebei province), Ding ware was made in thinly potted shapes and with varied decoration, often inspired by contemporary silver, gold and lacquer vessels. As tea drinking became fashionable, Ding ware tea bowls also became increasingly valued at the Northern Song court and at monasteries.

This Ding bowl with petal-lobed rim was first thrown on a wheel and then made thinner by shaving the exterior. The inner surface was decorated with naturalistically rendered ducks swimming among reeds, drawn with fluently incised and combed lines. Based on the belief that ducks mated for life and died of sorrow if separated, this classic Song dynasty motif symbolized a wish for a long, faithful and happy marriage.

Northern Song potters used an ingenious and economical method of firing the glazed Ding bowls: they inverted them on their rims, wiped free of glaze. The bowls were stacked on supportive setters in saggars (refractory ceramic boxes) that kept the bowls from warping and protected them from flames and ash in the kilns. After the "upside-down" (*fushao*) firing, the unglazed rims were often disguised and embellished by fitted metal (copper, bronze, silver or gold) bands, many made in special imperial workshops.

Ding ware gained its characteristic warm hue in the 10th century when the fuel of its *mantouyao* ("bun kilns") was changed from wood to coal. When fired in oxidation at high heat (1280-1350ºC), the kaolinitic clay component of the glaze with its traces of iron tinged the transparent glaze to an ivory color. The creamy Ding ware glaze is considered unique in its composition among Chinese glazes. It is low in calcium, alkalis and titanium and rich in silicon, aluminum and magnesium, the latter ingredient its major flux.

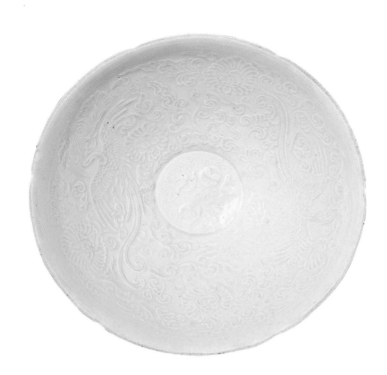

Bowl with Motif of Two Phoenixes and Chrysanthemum Sprays
12th century, Northern Song (960–1127) or Jin Dynasty (1115–1234)
North China, Hebei province
Northern whiteware: Ding ware
Porcelain with mold-impressed motifs under a transparent, kaolin-rich glaze
Museum purchase (formerly John Chandler Bancroft Collection), 1954.120

As the demand for the elegant Ding ware increased during the Northern Song dynasty, efficient techniques were instituted to augment production. For example, incised motifs were increasingly replaced by dense mold-impressed designs. The designs were often inspired by the lively, stylized patterns seen on contemporary silk tapestries (*kesi*), embroideries and dishes of beaten silver.

This bowl was first created on a wheel, beaten thin over a convex, hard-fired pottery mold and finished with six tiny rim indents to give it a floral form. The design is very similar to patterns seen on extant molds, as for example, a mold dated 1184, owned by the Percival David Foundation in London.

Production of Ding whiteware continued at a reduced level at the Quyang kilns (Hebei province) after the kilns fell under the control of the Jin Tartars in 1127 and the Northern Song court fled south. Ding ware experienced its final decline in popularity in the 13th century, after the Mongol invasion in 1234.

Medallion-Pattern Bowl with Design of Ducks, Lotus and a Pair of Fish

Late 11th or early 12th century, Northern Song dynasty (960–1127)
North China, Shaanxi province
Yaozhou ware ("Northern celadon")
Stoneware with mold-impressed designs under a lime-alkali glaze, tinted by iron and titanium
Stoddard Acquisition Fund, 2008.46

Detail from Medallion-Pattern Bowl. See page 82.

"Celadon" is a Western term referring to various shades of gray-green, blue-green or olive-green. The term is also used to refer to greenwares (*qingci*) with glazes of such nuances. The Chinese appreciation of greenwares is closely linked with their passion for jades. Yaozhou greenware was developed during the 10th century and was soon produced in kiln complexes in at least three provinces in North China, the nucleus being the kilns in Shaanxi province. Yaozhou ware is often called "northern celadon" in order to distinguish it from Longquan ware produced in South China, known as "southern celadon."

Yaozhou ware was made of fine-grained stoneware clays in expressive shapes influenced by contemporary metalwork and lacquers. Unlike classic Longquan ware (cf. 1996.98), which was sometimes deliberately under-fired, Yaozhou ware was fully fired in reduction at the higher temperature of about 1280–1300ºC, in a coal-fired *mantou* kiln. Compared to the thick Longquan ware glaze, which had a smooth, slightly "oily" texture, the Yaozhou ware glaze was thinner and more transparent. Furthermore, it had a warmer fresh-green or olive-green hue due to slightly higher amounts of iron and titanium impurities present in a higher titanium-to-iron ratio in its clay-body-material. Minute bubbles and surface pitting also gave the Yaozhou ware glaze a silken sheen and texture.

Emulating Ding ware decoration, Yaozhou ware was at first often carved and incised and then increasingly mold-impressed in order to save time and labor. A freshly thrown clay bowl would be inverted and pressed onto a master-mold upon which designs had been carved on the exterior before firing. Gaining a positive relief-imprint on its inside surface, the newly mold-impressed bowl would then be glazed and fired.

Compared to Ding whiteware, Yaozhou ware had the advantage of the contrast given to the decoration by its darker stoneware body and the feldspathic glaze that pooled darkly in the carved or molded areas of the decorative design. The rare medallion pattern on this deep molded bowl reflects a creative synthesis of Ding ware motifs and Tang dynasty designs influenced by Central Asian works. Six medallions with alternating naturalistic designs of ducks and lotus flowers form a circle around a central, six-petal flower medallion featuring two fish. Since ducks and lotus, as well as paired fish, symbolize a wish for matrimonial bliss, a dish like this would have been a suitable wedding gift.

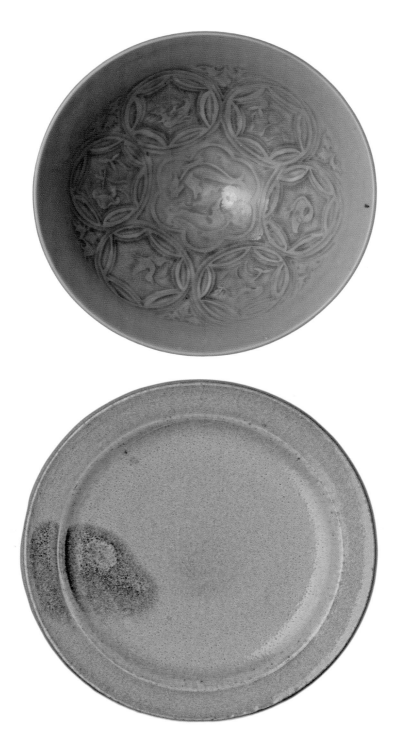

Small Blue Dish with Purple-Red Splash
12th century, Northern Song dynasty (960–1127) or Jin dynasty (1115–1234)
North China; Henan province
Jun ware
Stoneware with optical blue lime-alkali glaze with a copper solution splash
Stoddard Acquisition Fund, 2008.47

Jun ware, known for its sensuous, opalescent blue glaze, was first made at kilns in the Yu and Linru counties of Henan Province during the Northern Song dynasty. By the Yuan dynasty, Jun ware kilns had also been established in Hebei and Shanxi Province, and production is believed to have continued into the early 15th century.

Jun ware consisted of mostly simple, unpretentious, robust stoneware shapes that became widely popular among the middle classes. This small circular dish was thrown on the wheel and provided with a hand-carved foot-ring. After biscuit firing, the body was coated with a layer of glaze, placed in a protective saggar and fired in a kiln (1250–1300ºC). The thick, high-silica lime alkali glaze, with its minute bubbles and slight surface pitting, was very difficult to produce. It required great control in measuring, selecting, grinding and mixing the raw materials, as well as a very long, high firing in reduction and a very slow cooling in oxidation.

The blue color of the Jun ware glaze was mainly derived from an optical glass emulsion effect. During the firing and cooling process, the Jun glaze, with its carefully calculated silica and alumina levels, underwent a spontaneous liquid-liquid phase separation. In this separation minute, well-dispersed, light-scattering glass droplets that were rich in calcia, iron and copper became suspended in the glaze matrix. This glass emulsion reflected blue light, while all other light waves passed through the glaze. Adding to the soft, diffuse appearance of the glaze, a thin layer of light-reflective anorthite (lime feldspar) crystals developed between the body and the ground of the glaze in the cooling process.

When glazed and dried, but still unfired, this Jun ware dish (page 82, bottom image) was decorated with a copper-tin pigment splash. During firing at full heat, the splash merged with the underlying bluish glaze, turning red, purple, plum and sometimes even green. Early Jun wares had rather timid copper blushes, but later, especially during the Jin dynasty, these splashes became increasingly bold. While the technique is reminiscent of the earlier Tang dynasty splashed blackware (see 1953.82), the use of copper-oxide red makes Jun ware a precursor of the later oxblood, peach bloom and flambé porcelain glazes (see 1916.6, 1916.5, 1954.116, 1954.118.1).

Small Bowl with Melon-shaped Body
11th or 12th century, Northern Song dynasty (960–1127)
North China, Hebei-Henan provinces
Cizhou ware
Stoneware coated with white slip and dark slip-pigment tinted by magnetic
iron oxide, under a transparent, low-lime glaze
Museum purchase, 1958.41

Cizhou ware is a general term for the popular utilitarian ceramics produced at
a variety of kilns surrounding Cizhou, Hebei province near the border shared
with Henan province. During the Northern Song period and later, Cizhou ware
was widely used by middle class bureaucrat and merchant families.

The stoneware bodies of Cizhou ware are gray or buff and somewhat coarse.
In order to camouflage its rustic body, this Cizhou bowl was dipped in a white
porcelain-clay slip. Brownish-black dots of slip, mainly colored with magnetic
iron oxide (magnetite), were also added. Finally, the vessel was covered with
a thin, transparent low-lime glaze and fired in an oxidizing-to-neutral atmos-
phere at high temperatures of about 1240–1290°C.

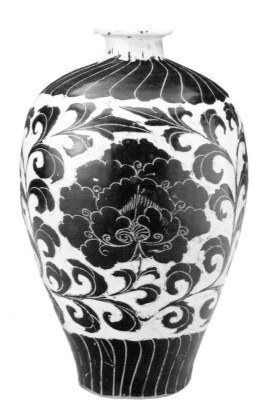

Large Meiping Vase with Sgraffito Design of Peonies
11th or 12th century, Northern Song dynasty (960–1127)
North China, Hebei-Henan provinces
Cizhou ware
Stoneware coated with a white slip and a dark slip-pigment tinted by magnetic
iron oxide, under a low-lime transparent glaze
Bequest of Margaret C. Osgood, 1958.2

Meiping means "plum vase." Vessels of this shape were originally made for
alcoholic beverages. Later they were mostly used to display a single plum
blossom branch. The light gray stoneware of this vase was first covered with a
layer of white slip and then with a brownish-black slip. Next the potter adorned
the vase with a *sgraffito* ("scratched") peony design. This "cut-glaze" design
was achieved by incising veins and outlines and scraping away background
areas through the brownish-black slip in order to reveal the white of the under-
lying slip. A clear glaze was then applied over the entire vessel. Of all the deco-
rative techniques used in Cizhou ware production, *sgraffito* was the most
luxurious and complex.

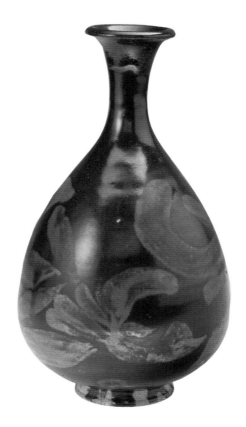

Pear-shaped Bottle with Design of Two Stylized Birds in Flight
12th or early 13th century, Jin dynasty (1115–1234)
North China, Henan Province
Northern blackware of Cizhou type
Stoneware with iron-rich lime-alkali glaze and decoration in russet iron oxide slip
Alexander H. Bullock Fund and Eliza S. Paine Fund, 1993.37

Ceramic pear-shaped bottles originated in the 11th century, copying similarly shaped vessels made of silver. Bottles of this form were primarily used for serving wine. Different iron-oxide glazes were used for the decoration and the background of this bottle. After the piece was fired in oxidation at about 1250–1320ºC and then cooled, the slight reduction in the amount of iron in the slip-glaze of the bird design made it stand out lighter in contrast to the blackish glaze of the background. The two abstractly-painted birds were depicted with bold, calligraphic strokes and from two perspectives: the heads are painted in profile and the bodies and feathered wings seen as if from above.

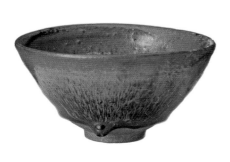
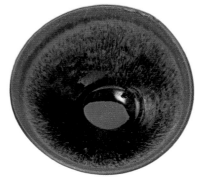

Two Tea Bowls with "Hare's Fur" Streaking
12th or 13th century, Northern Song dynasty (960–1127) or Southern
Song dynasty (1127–1279)
South China, Fujian province
Jian ware
Coarse-grained stoneware with iron-rich lime-alkali glaze with
iron-oxide streaks
Gift of Mabel Carleton Gage, 1935.142; 1935.143

As the custom of drinking tea grew in Fujian province and the popularity of
tea competitions spread throughout Chinese society, the demand for Jian ware
tea bowls made in Fujian also increased. Many fine Jian bowls were exported
to Japan and Korea but the very best were sent to the imperial court and major
monasteries.

These two Jian bowls are both of the "narrow-mouth" style and embellished
with the "hare's fur" (*tuhao*) effect. Featuring steeply pitched walls, the bowls
were fashioned to enable tea competitors to whisk their powdered green tea
and hot water until light and frothy. Concave indentations beneath the lips
made tea drinkers sip and savor the tea more slowly. The Northern Song
Emperor Huizong (1101–1125) and the cultural elite praised the beauty of the
white tea-froth, contrasted against the dark glazes of Jian ware bowls.

Each bowl was wheel-thrown and, after drying, immersed in a lustrous, iron-
tinted brownish-black or bluish-black glaze. Once the dark glaze coating had
dried, the bowl's lip was dipped in another highly iron-rich glaze solution. The
bowl was then placed on a small clay disk inside a protective clay saggar. Fired
in the oxidizing to a neutral high-firing atmosphere (1300–1330ºC) of a climbing
dragon kiln (*longyao*), the glaze underwent a transformational liquid-liquid
phase separation. Melting off the lip, a "hare's fur" effect appeared when pure,
tiny iron-oxide droplets bubbled, crystallized out, and formed streaks on the
surface of the glaze. "Hare's fur" streaks, as well as the glaze that pooled at the
bottom and the thick exterior glaze, were highly appreciated by connoisseurs.

Bowl with Lotus Flower Design
Early to mid-12th century; Northern Song dynasty (960–1127)
to Southern Song dynasty (1127–1279)
South China, Longquan in Zhejiang province
Longquan ware ("Southern celadon")
Porcelaneous ware with lime glaze, tinted by traces of iron and titanium
Bequest of Charles B. Cohn in memory of Stuart P. Anderson, 1985.116

From the 10th century until the early 18th century, the kilns in Longquan county produced a greenware that is popularly known as "southern celadon." This term is used to distinguish it from "northern celadon," or Yaozhou ware (cf. 2008.46). The earliest Longquan ware imitated the long-established grey-green Yue ware (produced for centuries in northeastern Zhejiang until the early 12th century). However, during the late 11th and early 12th centuries, the Longquan kilns experimented with numerous celadon glazes, all differing in nuance due to varying ratios of titanium to iron in the raw materials (e.g., duck-egg blue, blue-green to sea-green).

According to shards uncovered in recent excavations, this bowl, with its sparse, carved decoration of lotus blossoms and thin, frosty, pale grayish-green lime glaze, can be dated to the early or mid-12th century. Its thick-walled lower portions prevented the silicon-rich clay from warping in high-firing temperatures (about 1300°C).

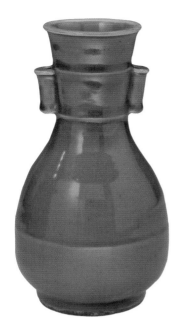

Hu-shaped Vase with Tubular Handles
Southern Song period (1127–1279)
South China, Longquan in Zhejiang province
Longquan ware ("Southern celadon")
Porcelaneous ware with multi-layered lime-alkali glaze, tinted by traces of iron and titanium
Stoddard Acquisition Fund, 1996.98

The kilns at Longquan and neighboring counties expanded production to meet demands when the imperial court, fleeing the Jin Tartars, moved south to establish the Southern Song dynasty and a new capital at Hangzhou (then called Lin' an), in Zhejiang province. In the late 12th century, experimentation with different glaze reformulations, firing temperatures and placement within the kiln, resulted in an opaque, even bluish-green celadon glaze characteristically associated with classic Longquan ware. As exemplified by this vase, vessels embellished with such a glaze were made of fine-grained porcelaneous stoneware and were often conceived as contemporary reinterpretations of ancient ritual bronze shapes.

The lustrous, thick Longquan glaze was mainly composed of limestone, supplemented with a small amount of wood ash and petuntse with low titanium to iron ratio. To create this remarkably tough glaze, a single coating was applied after an initial low biscuit firing of the body. Three to seven more glaze coatings, followed by low-temperature firings, were needed before the wares finally were re-fired in reduction at a higher temperature (about 1220–1250°C). An under-firing of the Longquan ware glaze (which fully develops at about 1250 °C)—facilitated by more flux—gave it a smoother, "oilier" quality.

The pure, white porcelain-stone clay used for the classic Longquan ware was usually deliberately adulterated with iron-rich clay. When re-oxidized in the cooling stage, the iron-rich, pale-grey porcelaneous clay mixture of the bodies gained a warm tone under the glaze, and unglazed areas turned a rusty color (notice foot of vase) that vividly complemented the celadon glaze.

Longquan became one of the three most flourishing kiln complexes in South China, along with Jingdezhen in Jiangxi province and Dehua in Fujian province. As Longquan ware became increasingly popular during the 13th and 14th centuries, its production became enormous. Twenty-five thousand vessels could be fired at one time in an elongated dragon kiln (*longyao*); many of these works were exported to countries along the maritime silk route.

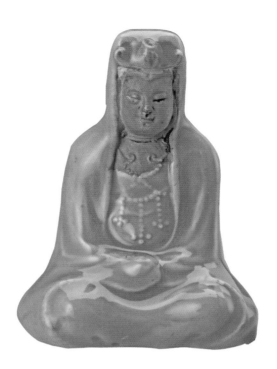

Small Seated Figure of Guanyin
15th century, Ming dynasty (1368–1644)
South China, Zhejiang province
Longquan ware ("Southern celadon")
Porcelaneous ware and lime-alkali glaze, tinted by traces of iron and titanium
Bequest of Mrs. Harry W. Goddard, in memory of Harry W. Goddard, 1938.44

Destined for a small home altar, this figurine representing Guanyin, the Buddhist Bodhisattva of Mercy, attests to the long and successful history of the Longquan kilns. The local petuntse clay, mixed with iron-rich clay, turned a reddish tint when fired without glaze. The effect was successfully used in this sculpture, giving Guanyin's unglazed face and chest a warm, rusty color, in striking contrast to the celadon glaze of her robe.

While Longquan-ware vessels were widely exported, figurines such as this were primarily made for the domestic market. In the 15th and 16th centuries, the rise in popularity of Jingdezhen porcelains caused a marked decline in the Longquan ware markets and production.

Detail from Bowl with Design of Two Boys Playing amidst Chrysanthemums. See page 92.

During the Five Dynasties (907–960) the potters at the Jingdezhen kilns in South China mastered the techniques, shapes and decoration of early northern Xing and Ding whiteware and southern Yue greenware. Using fine local petuntse clay, and a glossy, transparent *qingbai* ("bluish-white") lime glaze, they gradually perfected a hard and translucent type of white-bodied ware, called *quingbai*, which became a type of "folk porcelain." Manufactured until the 14th century, *qingbai* ware became the forerunner of the many refined and varied Jingdezhen porcelains of later centuries. *Qingbai* gradually went out of fashion from the end of the 14th century and into the Ming dynasty (1368–1644), replaced by a fascination with blue-and-white Jingdezhen porcelain.

Also known by the 20th-century term *yingqing* ("shadow-blue"), the *qingbai* glaze has been likened to unblemished jade and to the "clearing sky after a heavy rainfall." The bluish tint of the glaze emerged during the firing (with wood in a reducing atmosphere at 1220–1260ºC), due to the fact that its petuntse component was very low in titanium and thereby allowed the dissolved iron oxide to dominate. Bowls were fired upside down, the rim being left unglazed.

The finest *qingbai* vessels, such as the two bowls on the next page, were embellished with designs rendered in fluidly incised strokes, combined with combed or stippled details. The *qingbai* glaze pooled in the carved decoration, showing it off to great effect. The popular motif of boys among flowers (see detail above) was Indian in origin and inspired by Buddhist paintings. In China it came to symbolize wishes for fertility and male descendants. As the production of *qingbai* ware grew in response to popular demand, mold-impressed designs gradually replaced the carved ones in order to facilitate mass production.

Bowl with Chrysanthemum Scroll Motif
Late Northern Song Dynasty (1042–1127)
South China, Jingdezhen in Jiangxi province
Southern whiteware: *qingbai* ware
Porcelain with incised and combed decoration under a transparent, lime-rich,
siliceous porcelain glaze, tinged *qingbai* ("bluish-white") by traces of iron
Museum purchase, 1953.86

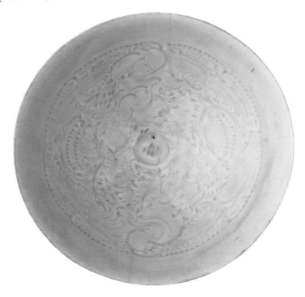

Bowl with Design of Two Boys Playing Amidst Chrysanthemums
Late Northern Song Dynasty (1042–1127)
South China, Jingdezhen in Jiangxi province
Southern whiteware: *qingbai* ware
Porcelain with incised, carved and combed decoration under a transparent, lime-
rich, siliceous porcelain glaze, tinged *qingbai* ("bluish-white") by traces of iron
Gift of Raymond Henniker-Heaton, 1923.20

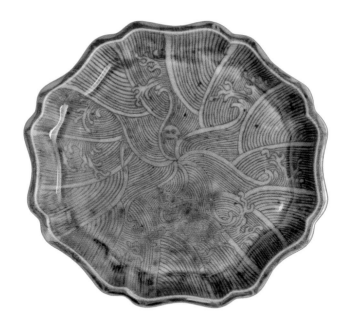

Mallow-shaped Tripod Dish with Fish and Wave Motif
Late Yuan dynasty (1279–1368)
The painted inscription on the bottom of this dish reads: "Hsuan-ho ware; (made in) the first year of the Zhizheng era (1341) of the Yuan, Jiang Qi copy number three." The inscription refers to Jiang Qi, who recorded all aspects of Jingdezhen porcelain-making in his book *Taoji* (The Record of Ceramics) dated 1322 or before.
South China, Jingdezhen in Jiangxi province
Jingdezhen ware: porcelain with copper-red under-painting and a transparent, lime-rich, siliceous porcelain glaze, tinged *qingbai* ("bluish-white") by traces of iron
Museum purchase (formerly John Chandler Bancroft Collection), 1954.114

This rare flower-shaped dish, with fish cavorting among waves, has long been treasured even though it exemplifies some of the difficulties encountered by Jingdezhen kiln potters of the early to mid-14th century. The porcelain body was warped in the kiln despite being supported by the numerous spurs, the remnants of which are visible on the back. In addition, the experimental copper-red pigment of the painted design diffused, blurred and turned brownish red or burnt gray under the transparent, fluid, *qingbai* ("bluish-white") glaze, used here as an overglaze. By the middle-to late 14th century, a new, colorless transparent lime-alkali glaze made of special glaze stones that could both cover and preserve the definition of the painted decoration had replaced the *qingbai* glaze as an overglaze on Jingdezhen porcelains.

Wine Cup with Applied Plum Blossom Decor
16th or 17th century, late Ming (1368–1644) or early Qing dynasty (1644–1911)
South China, Fujian Province
Dehua ware
Porcelain with applied biscuit relief decoration and a translucent ivory-toned alkali-lime glaze
Museum purchase (formerly John Chandler Bancroft Collection), 1954.110

Whiteware made of exceptionally pure petuntse and covered with white slip glazes began to be manufactured in the mountainous Dehua area of Fujian province in the 10th century. Dehua tableware, tea pots and figurines were widely exported and found their way to Europe during the Ming dynasty (1368–1644). Favored by European aristocrats and wealthy merchants, Dehua ware became known by the French term *blanc de Chine* (literally "white of China").

The clay used to make Dehua ware consisted of locally mined high-silica and high-potassium petuntse. This clay differed from the more plastic clay made of both petuntse and kaolin used at Jingdezhen, which could easily be shaped on the potter's wheel. As exemplified by this wine cup, the less plastic Dehua clay was best suited for small vessels and for the use of molding and carving techniques.

The white slip-glazes used to cover Dehua ware consisted of the local petuntse and a mixture of lime and potash (glaze ash). As the white clay body and the glaze were fired, they fused, giving the illusion of a single white and translucent material. During the Ming dynasty Dehua pieces (which hardly contained any traces of iron impurities) were generally high-fired in oxidation, creating warmer white tones. Both oxidizing and reducing techniques were used during the Qing dynasty, the latter technique creating colder whites. After 1750, the glazes tend to be a uniform cold pearly white.

This early wine cup is shaped to resemble a cup made of rhinoceros horn, a rare, costly material believed by the Chinese to promote health and longevity. Its plum blossoms, symbolizing renewed vitality, are an applied motif that was very popular during the late Ming and early Qing periods.

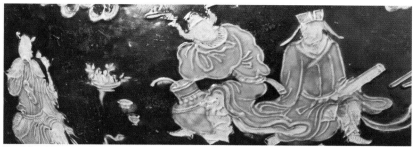

Detail from Wine Jar with Design of Eight Taoist Immortals and Eight Buddhist Symbols. See page 96.

JINGDEZHEN PORCELAINS

Jingdezhen in Jiangxi province, South China, was a flourishing center for porcelain production from the late Yuan dynasty onwards. Surviving political unrest and warfare in the mid-17th century, Jingdezhen became the premier site for porcelain manufacture during the Qing dynasty. This was especially true from 1683 onwards when it was chosen as the center for an imperial kiln complex commissioned to supply the imperial court with porcelains.

During the Kangxi (1662–1722), Yongzheng (1723–1735) and Qianlong (1736–1795) reigns, when China enjoyed one of its greatest periods of prosperity and political stability, Jingdezhen porcelain wares became increasingly elegant and elaborate. High quality ceramic production was stimulated by imperial interest in ancient and contemporary arts as well as by the appointment of a succession of very capable supervisors to oversee the imperial kilns. In a spirit of retrospection as well as artistic and technical exploration and innovation, extremely fine wares were produced, especially from 1683 to 1756. Highly skilled potters created great quantities of porcelains in varied, sophisticated shapes, decorated with a great range of refined glazes and decorations.

During the time of their greatest productivity (late 17th to the 20th century), the major manufacturers at the "porcelain capital" Jingdezhen achieved a higher output by using new egg-shaped kilns, known as "Jingdezhen kilns" (*zhenyao*), which enabled shorter and less costly wood firings. It was also possible to produce different types of wares during a single firing since different temperatures and both reducing and oxidizing atmospheric conditions existed in various spots within the *zhenyao* kilns. Most of the wares produced were high-fired porcelains, with the distinct advantage of only requiring one firing for body and glaze.

Jingdezhen is still a major exporter of porcelain to Asian countries and the main producer of porcelain tableware for domestic use. Contemporary porcelain production, using mostly coal, electricity and oil-fired kilns, exceeds 400 million pieces a year.

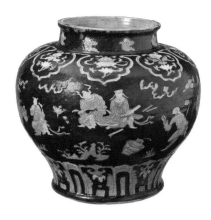

Wine Jar with Design of Eight Taoist Immortals and Eight Buddhist Symbols
Wanli period (1573–1620) of the Ming dynasty (1368–1644)
Jingdezhen, Jiangxi province
Fahua ware
Porcelain with designs in trailed slip and alkali-lead glazes
Museum purchase, with support from Mrs. Helen Bigelow Merriman, 1908.35

Fahua ("designs within borders") is ceramic ware with alkali-lead glazes that was inspired by cloisonné metalwork. First produced in Shanxi province, North China, during the Yuan dynasty (1279–1368), *fahua* ware was made of biscuit-fired stoneware covered with a white-clay slip to provide a bright ground for the colored glazes. By the mid-15th century, large *fahua* vessels, such as this wine jar (*guan*), were also being produced in South China at Jingdezhen. These southern *fahua* vessels used hard-fired, white porcelain (without need for a slip) and glazes with a lower lead content. Fahua ware remained popular in China until the Qing dynasty (1644–1911) but was rarely exported.

Characteristic of *fahua* ware, the designs on this wine jar were created with raised lines of clay-slip from a bag with a tube, and added, incised details. The unglazed porcelain body was then vitrified in a high temperature firing. Reminiscent of the technique of cloisonné metalwork, the cells created by the slip-lines were then filled with the vitreous, alkali-lead based fahua glazes colored with mixtures of cobalt, copper, iron and manganese oxides. Two of the most characteristic colors used in Chinese cloisonné metalwork as well as in *fahua* ware were the cobalt-tinted dark blue and copper-tinted turquoise. The whites are the porcelain body showing through a transparent glaze. As exemplified by this jar the inside of *fahua* vessels was often covered with a copper-tinted light-green glaze. With potassium oxide as the main flux, the glazes were fixed by means of a relatively low-temperature firing (850–950°C) in an oxidizing-to-neutral atmosphere.

The body of this wine jar is embellished with a design of the Eight Taoist Immortals (*baxian*) in a landscape setting. The neck is embellished with cloud forms and the foot with a band of stylized lotus petals. The Eight Auspicious Symbols of Buddhism (*bajixiang*), enclosed within *ruyi*-shaped lappets, surround the shoulder of the vessel.

Detail from Beaker Vase with Design of
Figures in a Mountainous Landscape.
See page 99.

BLUE-AND-WHITE PORCELAIN

Ever since the Tang dynasty (618–906), cobalt oxide had been imported in small amounts to China from the Middle East. During the Yuan dynasty (1279–1368), the ruling Mongols facilitated the importation of much larger supplies from the Middle East and Central Asia, stimulating the production of blue-and-white porcelains at Jingdezhen in Jiangxi province.

The production of blue-and-white ware was also facilitated by the increasing reliance on local, pure kaolin, "China clay," as a vital component of the clay bodies. A clear lime-alkali glaze, made with special glaze stones rather than with the clay of the porcelain bodies, was also developed. This new glaze was ideal since it preserved the definition of the cobalt blue underglaze painting (cf. unsuccessful attempts with copper-red underglaze painting: 1954.114).

To embellish a blue-and-white vessel, a design was brushed in cobalt blue pigment onto the unfired white porcelain claybody. The body was then completely covered with the clear lime-alkali overglaze and high-fired in reduction. The result was a vessel with motifs in brilliant sapphire blue, stunningly contrasted against a lustrous white body.

Blue-and-white porcelains began to be widely exported to Southeast Asia, Europe, and the Islamic world during the Ming dynasty (1368–1644). The ware became increasingly elegant and even in quality during the Kangxi period (1662–1722) as potters further purified the local porcelain clays, developed an even clearer, colorless glaze, and used refined cobalt ore processed from local deposits.

Globular Vase with Stylized Peony Scroll Design
Early 15th century, Ming dynasty (1368–1644)
Jingdezhen, Jiangxi province
Blue-and-white ware: porcelain with decoration in high-iron cobalt blue
pigment under a clear lime-alkali glaze
Museum purchase, 1959.6

This globular vase, with its tall, slightly flaring neck, is a superb example of the highest quality early blue-and-white ceramics created at the Jingdezhen kilns. After the final turning on the potter's wheel, this large vase was dried in the sunlight. Its white porcelain body was then embellished with stylized flower scroll designs on the body, neck and in a band below the rim, as well as an ornamental shoulder border of three-lobed pendants, all painted with a cobalt blue pigment. The entire vase was then covered with a thick, shiny and transparent glaze, before firing at a temperature of about 1270–1290°C to vitrify the clay, turn the cobalt into a bright blue, and fuse the glaze.

This early-15th century masterpiece was decorated with imported, iron-rich cobalt. This is evident from the way in which the cobalt, where thickly applied, diffused through the clear glaze, crystallizing out as dark magnetic iron specks to the surface of the glaze. The resulting darker cobalt-blue areas and slight blurring of the design, as well as the slight blue tinge of the transparent glaze, endow the decoration with subtle tonal variations and painterly effects. Jingdezhen potters sought to replicate such highly appreciated artistic effects during the 18th century. Using domestic manganese-rich cobalt that was lower in iron, they sought to imitate the "heaped" quality of the imported cobalt by applying thousands of tiny blue dots to their blue underglaze painting.

Beaker Vase with Design of Figures in a Mountainous Landscape
Kangxi period (1662–1722) of the Qing dynasty (1644–1911)
Jingdezhen, Jiangxi province
Blue-and-white ware: porcelain with cobalt blue decoration under clear
lime-alkali glaze
Museum purchase (formerly Emile F. Williams Collection), 1910.38

Inspired by classical paintings, this scene of mountains, water, a pavilion and
a distant hut is enlivened by figures. Included are a scholar with an assistant,
a man ferrying a boat with a pole, a man walking with a basket over his
shoulder and a fisherman with a large hat and a fishing pole (see p. 95). The
painterly style of the scene, in brilliant sapphire blue contrasted against a pure
white background, was highly favored among the increasingly prosperous and
educated middle classes who, like the literati, often dreamt of escaping
everyday life under the domination of the non-native Manchu dynasty. Like
many vessels of this type, this vase is also adorned with decorative bands; here
they are serrated, *ruyi*-and-cloud-design and petal-shaped bands. Blue-and-
white wares were offered for purchase in cities along the lower reaches of the
Yangtze River. From the end of the Kangxi period, they were increasingly
exported to Japan and Europe.

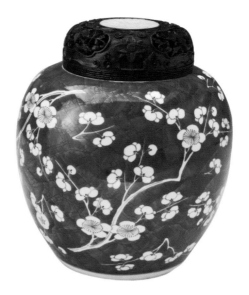

Jar with Plum Blossom and Cracked Ice Design
Kangxi period (1662–1722) of the Qing dynasty (1644–1911)
Jingdezhen, Jiangxi province
Blue-and-white ware: porcelain with cobalt blue under clear lime-alkali glaze;
pierced and carved ebony lid with nephrite medallion
Museum purchase (formerly J.P. Morgan Collection), 1916.4

The design of this jar depicts white plum blossoms bursting forth on bare branches, silhouetted against layers of cracked ice rendered in overlapping shades of blue. The reserved white design in a blue ground is a type of underglaze blue decoration that was first used during the Yuan dynasty (1279–1368) and perfected during the Ming dynasty (1368–1644). The technique first requires drawing the outlines of the design and then covering the background with cobalt blue. After applying an overall coating of clear glaze, the vessel is fired at a high temperature.

Popular during the Kangxi period (1662–1722), the plum-blossom design, which symbolizes rebirth and renewal at the end of winter, was often painted on covered jars produced to contain tea or preserved fruits. Such jars were given as presents at New Year and could also be used for ornamental display. From the mid-Kangxi period onwards potters also produced lower quality versions in great numbers. These lower quality jars with foodstuffs were exported to the West, where they became known as "ginger jars."

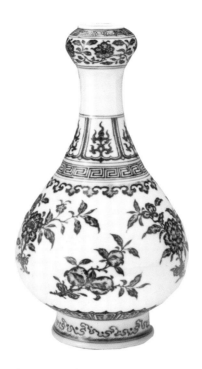

Garlic-head Vase with Design of Fruit and Floral Sprays
Yongzheng period (1723–1735) of the Qing dynasty (1644–1911)
Six-character (regular script) double-circle underglaze blue mark:
Da Qing Yongzheng nian zhi ("Made in the Yongzheng reign of the great
Qing dynasty")
Jingdezhen, Jiangxi province
Blue-and-white ware: porcelain with cobalt-blue decoration under clear
lime-alkali glaze
Bequest of Mary Harper Sheperdson, 1951.96

This elegant porcelain vase, with its gently rounded pear-shaped body and
design of fruit and floral sprigs, exemplifies the high-quality blue-and-white
ceramics appreciated by Chinese nobles and wealthy merchants during the
Yongzheng reign (1723–35). The three fruit branches represent "The Three
Abundances" (*sanduo*), namely citron, pomegranate, and peach, symbolizing
a long life of happiness, fertility and abundance. The foot is edged with
breaking waves and the base is surrounded by lotus petals. The bulbous mouth
with raised rim is encircled by a floral scroll. The upper part of the neck is
unadorned, but its lower part and the shoulder of the vase are decorated with
panels filled with flame motifs and bands with angular meanders and three-
lobed pendants. The shape of this garlic-head vase (*suantouping*) was first
rendered in bronze and pottery during the Qin and Han dynasties (221 B.C.–220
A.D.), and revived in ceramics beginning in the Song dynasty (960–1279).

HIGH-FIRED MONOCHROME GLAZES

Imperial patronage at Jingdezhen encouraged the revival of the finest forms and glazes of earlier eras as well as the development of innovative firing technologies to facilitate the production of new shapes and glazes. By the mid-to-late 18th century these major advances enabled the production of an extraordinary array of porcelains, including monochromes with exquisite colors and flawless surfaces that are especially treasured among connoisseurs.

Most of the high-fired monochrome glazes were produced using only a small number of metal oxides. For example, copper was used for oxblood, peach-bloom and flambé glazes; iron was essential in the production of celadon glazes as well as in the composition of iron rust and tea dust glazes; cobalt was the coloring agent for various blues; and "mirror black" was created through a combination of mainly iron, manganese, and cobalt.

Ox-Blood Red Mallet-shaped Vase
Kangxi period (1662–1722) of the Qing dynasty (1644–1911)
Jingdezhen, Jiangxi province
Porcelain with a lime-alkali glaze tinted with copper
Museum purchase, 1916.6

During the Kangxi period (1662–1722), Jingdezhen potters succeeded in reviving a more fluid version of the opaque, even-toned *jihong* "sacrificial-red" glaze, a copper glaze that had first been used for imperial ceremonial wares for the Altar of the Sun during the Xuande period (1426–1435). This revival of *jihong* also led to the experimental development of a more glass-like and lustrous red glaze with suspended copper oxide particles. In reference to Lang Tingji (1663–1715), who supervised the imperial kilns at Jingdezhen from 1705 to 1712, the new glaze was called *lanyaohong* (Lang-ware red). In the West the glaze was thought to resemble and thereby came to be popularly called "ox-blood," or *sang de boeuf*.

This vase (page 102) exemplifies an early variation of the new copper-red glaze. The impression is one of looking through a transparent, crazed surface, strewn with fine bubbles, to a warm red color where the glaze is thicker, and to a pale green tint, where the glaze has flowed thin at the lip and towards the foot. When applied more thickly and evenly, and fired at higher temperatures, this new glaze gained a darker red and more vitreous surface (cf. 1905.1).

Dark Ox-Blood Red Bottle Vase
Mid-to-late 18th century, Qing dynasty (1644–1911)
Jingdezhen, Jiangxi province
Porcelain with lime-alkali glaze tinted with copper
Museum purchase, 1905.1

The Lang-ware red (*langyaohong*) or "ox-blood" glaze, which was first developed in the early 18th century when the imperial kilns of Jingdezhen were supervised by Lang Tingji (1663–1715), continued to be adapted in the search for more brilliant reds. The dark, thick and vitreous glaze of this vase was created through a very liberal and even application of a copper-red glaze, fired at a high temperature.

The copper-red glaze was often used on contemporary vase forms. The shape of this vase places it in the "bestowal vase" (*shangping*) category. Bestowal vases were produced in large quantities during the Yongzheng (1723–1735) and later periods as gifts to meritorious court officials and esteemed envoys and guests.

Writer's Water Pot with Peach-Bloom Glaze
Kangxi period (1662–1722) of the Qing dynasty (1644–1911)
Six-character (regular script) underglaze blue mark:
Da Qing Kangxi nian zhi ("Made in the Kangxi reign of the great
Qing dynasty")
Jingdezhen, Jiangxi province
Porcelain with incised design, covered with layers of clear glaze tinted
by copper-lime pigment
Museum Purchase (formerly J.P. Morgan Collection), 1916.5

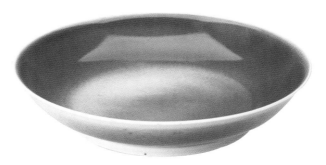

Flat Bowl with Peach-Bloom Glaze
Qianlong period (1736–1795) of the Qing dynasty (1644–1911)
Six-character (seal script) underglaze blue mark:
Da Qing Qianlong nian zhi ("Made in the Qianlong reign of the great
Qing dynasty")
Jingdezhen, Jiangxi province
Porcelain covered with layers of clear glaze tinted by a copper-lime pigment
Museum Purchase (formerly John Chandler Bancroft Collection), 1954.116

While experimenting with high-fired copper-red glazes during the Kangxi
reign, the potters at Jingdezhen invented a velvety, pinkish-red glaze. The
Chinese called this glaze *jiangdouhong* ("bean-red"); in the West it became
known as "peach-bloom glaze."

Potters and scholars now generally believe that this widely admired peach-
bloom glaze was created by first applying a coat of clear glaze onto an unfired
porcelain body. A layer of copper-lime pigment was then blown onto the clear
glaze by means of a bamboo tube covered at one end with silk gauze. The
covered end of the tube was dipped into the pigment, which was then blown
from the open end. One or two coats of clear glaze were subsequently applied
to sandwich the finely sprayed copper pigment.

While striving to achieve an even color, changes in the atmosphere in the kiln
gave rise to variegated tones that were equally appreciated by collectors. The
peachy-pink color emerged during the firing when the metallic copper
remained trapped to reflect light or dissolved in the glaze. Inconsistencies in
the reduction firing and cooling could cause areas where the copper pigment
clumped and seeped through the clear overglaze to re-oxidize as a pale liver
color, grayish-green or green. Where the glaze flowed very thin, it often turned
a very pale green tint. Areas of light pink or white occurred where the pigment
layer had been very lightly sprinkled, had flowed aside or been omitted.

The peach-bloom glaze was usually used for sets of elegant items destined for
use and display on the desks of scholars. The dome-shaped water pot (see
opposite page) is adorned with three incised archaistic dragon roundels and a
mottled glaze. Used to moisten and clean calligraphy brushes, the narrow neck
served to both remove excess water and bring the brush to a point.

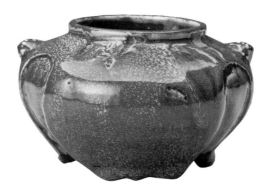

Incense Burner with Knob Handles and Flambé Glaze
About 1800, Qing dynasty (1644–1911)
Jingdezhen, Jiangxi province
Porcelain with a furnace transmutation glaze colored with copper and other metal oxides
Museum purchase (formerly John Chandler Bancroft Collection), 1954.118.1

Commissioned by the imperial court in Beijing to copy the Jun ware glazes created during the Song, the potters at Jingdezhen experimented with high-temperature copper-red glazes. While not succeeding in reviving the opalescent blue, bubble-filled Jun ware glaze with its purple-red copper solution splashes (cf. 2008.47), the potters developed spectacular flambé glazes. These lead-containing furnace transmutation glazes began to be used from about 1729 onwards.

As exemplified by this three-legged incense burner, the colors of thickly applied flambé glazes were dramatically transformed when fired at high temperatures. Due to low aluminum content, as well as the transmutation of colloidal copper, iron or other metallic materials into suffusions, flambé glazes turned blue, red, purple and even brownish-green. They also flowed, mixed, separated, streaked, mottled, bubbled and dripped, before finally smoothing into a glossy surface at the height of the firing. Vessels embellished with such striking glazes have popularly been called "Jingdezhen Juns."

Large Pale Celadon Vase with Phoenix Handles
Qianlong period (1736–1795) of the Qing dynasty (1644–1911)
Six-character (seal script) underglaze blue mark:
Da Qing Qianlong nian zhi ("Made in the Qianlong reign of the great
Qing dynasty")
Jingdezhen, Jiangxi province
Porcelain with a lime-alkali glaze tinted with iron and titanium
Museum purchase (formerly Emile F. Williams Collection), 1910.39

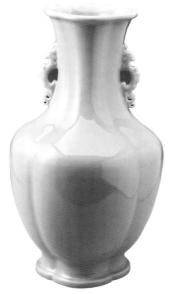

Small Pale Celadon Meiping Vase
Yongzheng period (1723–1725) of the Qing dynasty (1644–1911)
Six-character (regular script) double circle underglaze blue mark:
Da Qing Yongzheng nian zhi ("Made in the Yongzheng reign of the great
Qing dynasty")
Jingdezhen, Jiangxi province
Porcelain with a lime-alkali glaze tinted with iron and titanium
Museum purchase, 1916.10

Imperial monochrome porcelain vases with pale blue-green glazes, derived from
the classic celadon glazes (cf. 1996.98), were produced at Jingdezhen during the
Kangxi, Yongzheng and Qianlong reigns. The flawless *dongqing* ("winter green")
celadon glazes of these two vases help focus attention on their decorative details
and classic forms. The large, four-lobed vase is embellished with archaistic
phoenix design handles. The heads of the birds are complete with bills, combs,
and whirls on the bodies to indicate feathers. The small vessel is shaped like a
meiping ("plum vase"), a type of vase used to hold plum blossoms.

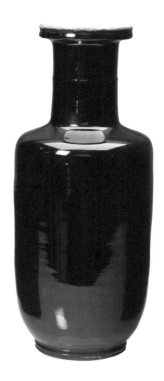

Mallet-shaped Vase with Mirror-Black Glaze
Kangxi period (1662–1722) of the Qing dynasty (1644–1911)
Jingdezhen, Jiangxi province
Porcelain with an exterior glaze tinted with iron, manganese and cobalt, and
an interior clear lime-alkali glaze
Museum purchase (formerly J.P. Morgan Collection), 1916.3

First produced at the imperial kilns in Jingdezhen during the Kangxi era, the
high-fired, lustrous, mirror black glaze was colored with a combination of
mainly iron, manganese and cobalt oxides. "Mirror black" is a western term.
The Chinese call the glaze *wujin* ("black bronze") after its main ingredient, the
local black bronze earth (*wujintu*) that has an iron content of 13.4 percent.
Wares with mirror-black ground were often decorated with painted gilt or
white designs. However, because of the fugitive nature of such decoration, it
often disappeared. No traces are visible on this vase.

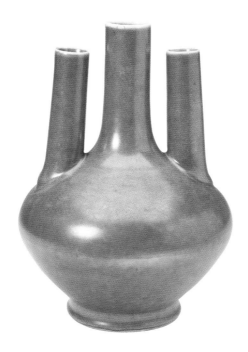

Three-necked Vase with Tea-Dust Glaze
Qianlong period (1736–1795) of the Qing dynasty (1644–1911)
Incised six-character (seal script) mark: *Da Qing Qianlong nian zhi*
("Made in the Qianlong reign of the great Qing dynasty")
Jingdezhen, Jiangxi province
Porcelain with an exterior iron-rich, crystalline glaze
Museum purchase (formerly John Chandler Bancroft Collection), 1954.127

The so-called tea-dust (*chayemo*) glaze had its origin in kilns of the Shaanxi and Henan provinces during the Tang dynasty. Created with iron, magnesium and silicic acid, this high-fired, crystallized glaze was perfected and produced in many subtle shades during the Qing dynasty (1644–1911), remaining popular at the imperial court well into the 19th century.

Large, imaginative and technically sophisticated vessels with velvety tea-dust glazes—such as this vase with three tall necks added to a rounded body—were made at Jingdezhen during the Yongzheng and Qianlong reigns. The iron-rich tea-dust glaze on this vase gained its crystalline, finely speckled yellowish-brown surface through a slight under-firing in gradual reduction (1200–1300ºC), followed by a slow cool-down.

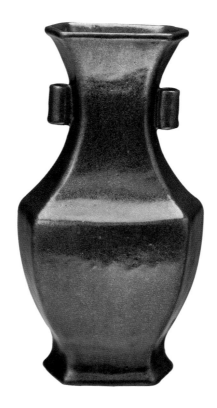

Faceted Hu-shaped Vase with Tubular Handles and Iron-Rust Glaze
Qianlong period (1736–1795) of the Qing dynasty (1644–1911)
Jingdezhen, Jiangxi province
Porcelain with a crystalline glaze rich in iron and manganese
Museum purchase (formerly John Chandler Bancroft Collection), 1954.119.1

The powerful Manchu ruler, Qianlong (r. 1736–95), a connoisseur of antiquities who aimed to "restore the ancient ways," encouraged his artisans to emulate the shapes and motifs of ancient and classic art works. This vase, with its flattened hexagonal shape, waisted neck flanked by a pair of tubular handles, is reminiscent of Song dynasty ceramics that emulated the shape of an ancient bronze *hu*. The vase is covered with a high-fired, crystalline "iron-rust" glaze (*tiexiuhua*) that was especially used during the Yongzheng and Qianlong reigns. Supersaturating the glaze with iron and manganese produced a dark reddish-brown color with bright metallic sheen, imitating bronze.

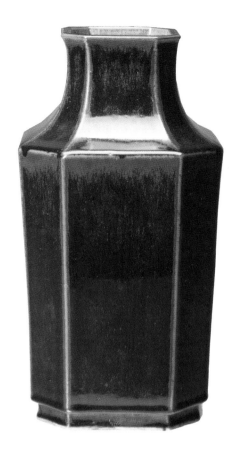

Octagonal Vase with Dark Brown Glaze
Jiaqing period (1796–1820) of the Qing dynasty (1644–1911)
Jingdezhen, Jiangxi province
Porcelain with an iron-rich glaze
Museum Purchase (formerly John Chandler Bancroft Collection), 1954.125.1

Depending on the amounts of iron and other metallic oxides, iron-rich mono-
chrome glazes of lighter and darker shades were produced at Jingdezhen,
ranging from yellowish tans to reddish browns and very dark browns. The
octagonal shape of this vase was first developed in the Jiaqing period but it
continued to be popular until the end of the Qing dynasty. Its appealing form
was emphasized by deliberately rubbing the glaze thin at the joins, where the
planes intersect.

Detail from Mallet-shaped Vase with Scene of an Archery Contest. See page 114.

JINGDEZHEN PORCELAINS WITH ENAMEL DECORATION

Many porcelain wares produced at Jingdezhen in Jiangxi province in southern China were decorated with enamels. Enamels are low-fired, glasslike glazes made with compounds of lead oxide and silica and tinted by a variety of metal oxides, such as iron, copper, cobalt and manganese. Known in China as early as the 12th century and greatly developed during the Ming dynasty (1368–1644), overglaze enamel decoration reached its fullest expression and technical perfection during the Qing dynasty (1644–1912). More precisely, according to the imperial archives in the Forbidden City, potters did not "perfect" enamels until 1728, the sixth year of the reign of Emperor Yongzheng.

As exemplified by porcelains in the Worcester Art Museum Collection, Chinese potters used enamels in several ways. Most frequently they employed them to paint decoration onto a porcelain body that had previously been glazed with a high-fired transparent glaze. The potters sometimes also adapted enamel glazes as monochrome glazes. Such a monochrome glaze would be applied over a basic transparent glaze. At other times the potters painted enamels directly "on the biscuit," that is onto a pre-fired, unglazed ceramic.

After being embellished with enamel decoration, porcelains were always re-fired at a relatively low temperature. This kind of firing caused the enamels to melt and bond with the underlying material. It also maximized the vibrancy of the coloring oxides, was fast, and economical.

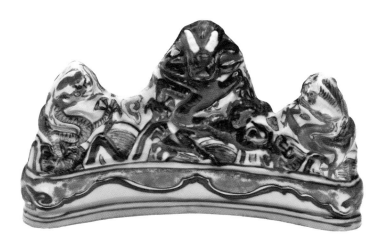

Brush Rest in the Form of Mountain Peaks
Late 16th century, Wanli period (1573–1620) of the Ming dynasty (1368–1644)
Six-character (regular script) underglaze blue mark in single line within a
double rectangle: *Da Ming Wanli nian zhi* ("Made in the Wanli reign of the
great Ming dynasty")
Jingdezhen, Jiangxi province
Porcelain with *wucai* style decoration: some motifs in underglaze cobalt blue
and the remaining motifs in overglaze black pigment (details and outlines)
and red, yellow and green enamels
Anonymous Loan, E.55.08

This crescent-shaped brush rest was molded in the form of a mountain range.
Reminiscent of patterns on Chinese imperial robes, the brush rest is decorated
with dragons and a band of waves and rocks below. The red, blue and green
dragons prance about and encircle the mountain peaks with their tails and limbs.

The lively polychrome decoration of black pigment outlines and details as well
as blue, red, green, yellow enamels, is representative of the *wucai* (literally "five
colors") style of later Ming period ceramics. The term *wucai* gradually became
synonymous with "multiple colors" since the style often made use of additional
enamel colors, sometimes amounting to more than five colors. According to
the *Annals of Jiangxi* (*Jiangxi Sheng Da Zhi*) five hundred brush rests with three
dragons among mountains in *wucai* style were commissioned in 1593.

The central dragon is rendered in an intense cobalt blue. The successful
production of Chinese blue-and-white ware at Jingdezhen had popularized
the use of cobalt blue, and the pigment also became appreciated as a perfect
complement to overglaze enamels in other vivid colors. Applying the cobalt
pigment under the glaze was necessary during the Ming dynasty since Chinese
potters did not develop reliable blue enamel for overglaze decoration until the
early 18th century.

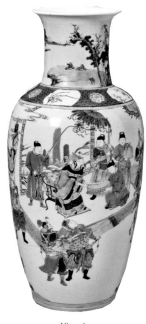
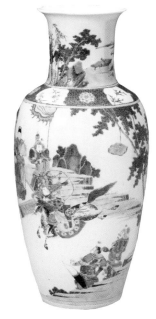

Mallet-shaped Vase with Scene of an Archery Contest
Early Kangxi period (1662–1722) of the Qing dynasty (1644–1911)
Jingdezhen, Jiangxi province
Porcelain with *famille verte* enamel decoration over transparent glaze
Bequest of Grenville H. Norcross, 1937.145

In the West, this Kangxi period vase would be described as exhibiting the *famille verte* ("green family") palette of enamels; the Chinese call this palette *yingcai* ("hard colors"). *Famille verte* enamels are brightly colored and mostly translucent, and they include several distinctive shades of green as well as yellow, brown, iron-red, blue, black and white (clear enamel over the plain porcelain surface). Polychrome enamels were applied within black (iron-manganese-cobalt) and iron-red outlines, as well as over black modeling strokes and details.

This vase can be dated to the early Kangxi period when it was fashionable to decorate porcelain with scenes from historical novels. In this case the scene may illustrate the archery contest scene in the *Romance of Three Kingdoms* written by Luo Guanzhong in the 14th century. The experimental grayish-blue enamel, which in areas failed to adhere to the underlying clear glaze (see white spots within bluish areas), also suggests the early Kangxi date. Although China was already famous for its widely traded blue-and-white ware using under-glaze cobalt blue, a dependable overglaze blue enamel was very difficult to achieve and was not perfected until the 1720s.

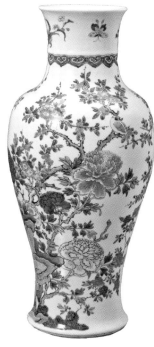

View A

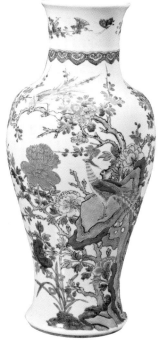

View B

Baluster Vase with Design of Birds, Flowers and Rocks
Yongzheng period (1723–1735) of the Qing dynasty (1644–1911)
Jingdezhen, Jiangxi province
Porcelain with *famille verte* enamel decoration over transparent glaze
Museum Purchase (formerly Emile F. Williams Collection), 1910.43

This early 18th-century vase exhibits the technical mastery that was possible with the *famille verte* ("green family") palette of enamels. The scene decorating the body includes two phoenixes and a small yellow bird amidst peonies and other garden flowers. Butterflies and floral sprays decorate the neck.

The designs were first outlined with a black (iron-manganese-cobalt) pigment and iron-red enamel before being colored with translucent overglaze enamels. Final touch-ups, emphasizing certain outlines, were made with black pigment. The decoration notably includes blue enamel that is bright and lustrous, showing a clear improvement over the experimental blue enamel used in the Kangxi period (cf. the mallet-shaped *famille verte* vase, 1937.145).

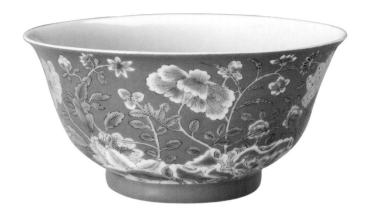

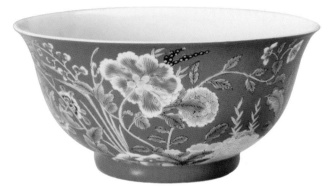

Pair of Bowls with Garden Flower Designs
Yongzheng period (1723–1735) of the Qing dynasty (1644–1911)
Four-character (regular script) double-square underglaze blue mark:
Yongzheng yu zhi ("Commissioned by Emperor Yongzheng")
Jingdezhen, Jiangxi province
Porcelain with *famille verte* enamel decoration over transparent glaze
Gift of Mr. and Mrs. Eugene Bernat, 1975.663.1-2

Thinly potted bowls with plain interiors and exquisite exteriors decorated with
a variety of flowers on an iron-red ground were produced in the imperial work-
shops of the Forbidden City in Beijing during the late Kangxi and early
Yongzheng periods. The flowers were first outlined in black and red and then
colored with enamel blues, greens, red, aubergine, brown, and yellow. The style
of the decoration and its strong *famille verte* colors were probably influenced
by contemporary Chinese cloisonné.

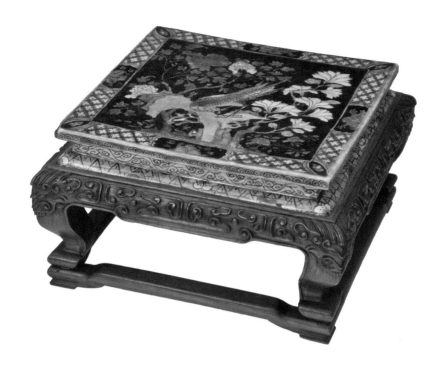

Vase Stand with Design of a Phoenix, Garden Rock, Peonies and Magnolias
Kangxi period (1662–1722) of the Qing dynasty (1644–1911)
Jingdezhen, Jiangxi province
Porcelain tile with *famille noire* enamel decoration on teak stand
Museum Purchase (formerly J.P. Morgan Collection), 1916.7

The decoration on this tile was rendered in the *famille noire* ("black family") palette, a variant of *famille verte* ("green family"). Its *famille noire* enamels were painted "on the biscuit," that is onto pre-fired, unglazed ceramic, in order to create a visual effect that is darker and less shiny that that of enamel painted on a glazed surface (cf. baluster vase 1910.43). Painting enamel on biscuit helped achieve a deep, dense black—a black created by layering translucent green enamel over a matte black pigment rich in impure Chinese cobalt, iron, and manganese. As exemplified by this vase stand, the *famille noire* palette usually also included green, yellow and aubergine enamels; the white is the porcelain body showing through clear enamel. Red enamel was rarely used since it required the addition of a transparent underglaze to support it. Like other enameled works, enameling "on the biscuit," required a second low temperature firing to fuse the enamels.

Iron-Red Vase with Flaring Lip
Late Kangxi period (1662–1722) of the Qing dynasty (1644–1911)
Jingdezhen, Jiangxi province
Porcelain with iron-red enamel glaze over transparent glaze
Museum Purchase, 1916.8

This vase is representative of how the matte iron-red enamel of the *famille verte* palette was often used as a low-fired overglaze, layered over a previously clear-glazed and high-fired porcelain body (see white of the throat). The use of such an overglaze enamel ensured far more reliable results than high-fired red glaze alternatives.

Small Yellowish Vase
Yongzheng period (1723–1735) of the Qing dynasty (1644–1911)
Jingdezhen, Jiangxi province
Porcelain with yellow enamel glaze over a stone-colored crackled glaze
Museum Purchase (formerly J.P. Morgan Collection), 1916.9

The unusual exterior surface effect was achieved by first covering the vase with a high-fired, stone-colored crackled glaze. After firing, this crackled glaze was covered with a translucent yellow enamel glaze. The bright camellia-leaf green of the lip and interior—most likely created by adding copper to a yellow lead-antimony glaze—was also applied before re-firing the vase at a lower temperature. The bright green glaze was used for only a short time, during the Yongzheng period and early in the succeeding Qianlong period (1736–1795); it was both difficult and dangerous to use, poisoning potters and patrons alike.

Baluster Vase with Floral Spray Designs
Qianlong period (1736–1795) of the Qing
dynasty (1644–1911)
Six-character (seal script) overglaze red
enamel mark: *Da Qing Qianlong nian zhi*
("Made in the Qianlong reign of the great
Qing dynasty")
Jingdezhen, Jiangxi province
Porcelain with *famille rose* enamel
decoration and incised enamel ground
over transparent glaze
Bequest of Mrs. Charles L. Morse, 1966.21

The flowers depicted on this vase include
delicate sprays of morning glories, chrysan-
themums, peonies, hibiscus, lotus blossoms
and camellias. The vase reflects the introduc-
tion at Jingdezhen, from the late 1720s
onwards, of a new palette of enamels, many with
components imported from Europe. The Chinese
often called this palette *fencai* ("pale or powder
colors"), *ruancai* ("soft colors"), or *yangcai*
("Western or foreign colors"). Referring to its
range of pink enamels colored by colloidal gold,
Westerners call this palette *famille rose* ("pink family"),
a term coined by a 19th-century French connoisseur.

The new *famille rose* enamels were sometimes used in combination with the
traditional, transparent Jingdezhen enamels. They also included the use of an
opaque lead-arsenate white and a lead-stannate yellow adopted from Chinese
cloisonné enameling on metal at the imperial workshops of the Forbidden City.
In porcelain decoration these white and yellow pigments helped create a widely
nuanced palette. For example, the colloidal pink was used alone or in combi-
nation with the white or yellow pigments to produce a wide range of color
tones. To gain different effects, enamel powders were also mixed with varied
media such as oil, liquid gum, or plain water.

The *famille rose* palette inspired the employment of professional painters to
embellish the finest porcelains. The creative use of pigments of graduated tones
and diverse consistencies enabled such artists to freely enhance their designs
with painterly modeling and shading techniques inspired by Western art. As
seen here, the enameled backgrounds of *famille rose* ware were often incised
with lively patterns for an even greater decorative effect.

Flattened Baluster Vase with Narrative Scenes and Borders with Flowers, Fruits, Insects and Auspicious Objects
Late Qianlong period (1736–1795) of the Qing dynasty (1644–1911)
Jingdezhen, Jiangxi province
Porcelain with *famille rose* enamel and gilt decoration over white porcelain glaze
Gift of Dr. Samuel B. Woodward, 1939.83

In the latter part of the Qianlong period, it became fashionable to embellish the entire surface of a porcelain body with enamel decoration, leaving little or no white ground showing. This vase is a good example of the growing trend for all-over design. On one side the master of a mansion is shown returning in a rickshaw, greeted by ladies and children on a veranda. On the other side he is depicted seated at a table, watching a servant pound rice in an interior court-yard. The lady of the mansion is depicted twice. On one side (seen here on the neck) she stands next to her older son who holds a fan; on the other side she is shown accompanied by her younger son. In the late 18th and 19th centuries, vases like this one were widely exported to the West.

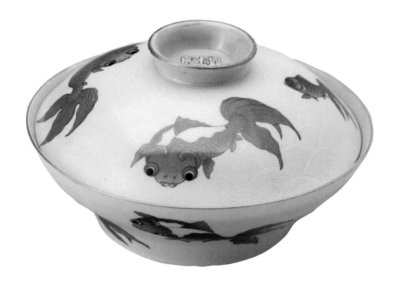

Covered Tea Bowl with Design of Swimming Goldfish
Daoguang period (1821–1850) of the Qing dynasty (1644–1911)
Four-character (seal-script) overglaze red enamel marks (on lid and bowl):
Jiezhu zhu ren zao "Produced (by or for the) Master (of) Jiezhu."
Jingdezhen, Jiangxi province
Porcelain with enamel decoration and incised enamel ground over trans-
parent glaze
Gift of Helen M. Fernald (formerly Helen Bigelow Merriman Collection),
2008.51

Decorated by skilled enamel artists, this covered tea bowl exemplifies a type of
ware that was very popular in the early 19th century. Set off by an opaque white
enamel ground with incised waves and foam, the playful goldfish were readily
understood as symbols of prosperity. The Chinese word for "goldfish" (*jinyu*)
is a homophone for "gold in abundance" (*jinyu*).

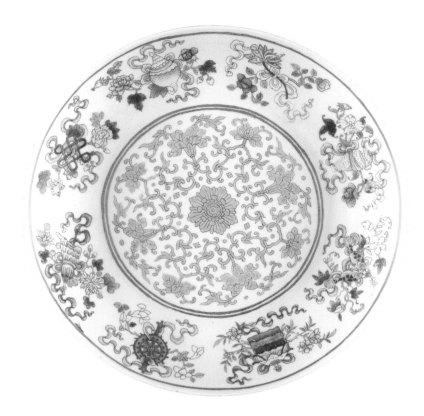

Dish with the Eight Buddhist Symbols and a Central Floral Scroll Medallion
Tongzhi period (1862–1874) of the Qing dynasty (1644–1911)
Six-character (regular script) underglaze blue mark: *Da Qing Tongzhi nian zhi* ("Made in the Tongzhi reign of the great Qing dynasty")
Jingdezhen, Jiangxi province
Porcelain with *famille rose* enamel decoration over white porcelain glaze
Gift of Mrs. William C. Thompson, 1901.9.2

Originally introduced to China along with Tibetan Buddhism during the Yuan dynasty (1279–1368), "The Eight Auspicious Symbols of Buddhism" (*bajixiang*) gradually lost their original significance as emblems of treasured aspects of Buddha's teachings. Instead they became increasingly used on ceramics and textiles as auspicious, decorative motifs associated with a long and happy life. The symbols are depicted surrounded by ribbons and flowers. They include the wheel of the law, a standard of victory, an endless knot, a conch shell, lotus, a treasure vase, twin fish, and a ceremonial parasol.

MEASUREMENTS OF CHINESE CERAMICS*

1901.9.2	4.2 x 24.8 cm	1954.49	6.1 x 21.6 cm
1905.1	39.3 x 24.0 cm	1954.50	4.8 x 10.5 x 8.9 cm
1908.35	34.6 x 34.7 cm	1954.51	7.0 x 11.3 cm
1910.38	43.5 x 22.0 cm	1954.110	6.0 x 9.5 cm
1910.39	58.4 x 33.0 cm	1954.114	4.3 x 25.1 cm
1910.43	47.6 x 20.5 cm	1954.116	4.6 x 20.6 cm
1916.3	46.2 x 18.5 cm	1954.118.1	10.3 x 16.5 cm
1916.4	24.3 x 21.0 cm	1954.119.1	26.3 x 14.0 cm
1916.5	8.5 x 12.5 cm	1954.120	6.5 x 18.9 cm
1916.6	46.0 x 21.0 cm	1954.125.1	33.3 x 17.0 cm
1916.7	12.1 x 18.0 x 18.0 cm	1954.127	36.4 x 26.0 cm
1916.8	24.1 x 12.0 cm	1958.2	31.8 x 19.0 cm
1916.9	15.7 x 8.0 cm	1958.41	7.0 x 10.8 cm
1916.10	14.0 x 12.0 cm	1959.6	43.3 x 34.6 cm
1923.20	7.0 x 21.0 cm	1966.21	45.4 x 20.5 cm
1935.142	6.5 x 12.0 cm	1975.663.1	7.0 x 13.0 cm
1935.143	6.5 x 12.0 cm	1975.663.2	7.0 x 13.0 cm
1937.145	45.5 x 21.0 cm	1985.116	8.2 x 19.5 cm
1938.44	11.5 x 8.5 cm	1993.37	29.8 x 18.0 cm
1939.83	31.1 x 17.0 cm	1996.98	24.1 x 14.0 cm
1951.96	28.0 x 17.0 cm	2008.46	7.9 x 20.7 cm
1953.82	10.5 x 12.5 cm	2008.47	2.5 x 11.7 cm
1953.86	4.6 x 19.0 cm	2008.51	6.8 x 11.3 cm
		E.55.08	10.2 x 16.6 cm

Measurements are given with height, width and depth.

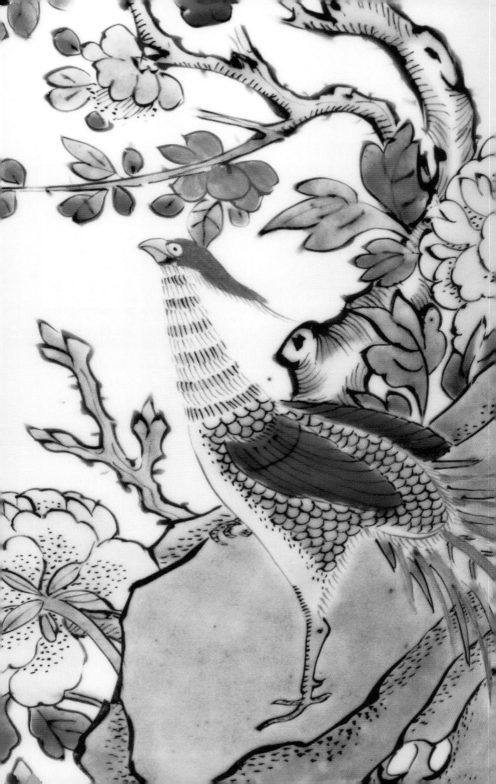

CHRONOLOGY

Neolithic Period	CA.7000–2000 BCE
Bronze Age	CA. 2000–221 BCE
Imperial Age	
Qin Dynasty	221–206 BCE
Han Dynasty	206 BCE–220 CE
Six Dynasties	220–589
Three Kingdoms	220–280
Jin Dynasty	265–420
Northern and Southern Dynasties	420–589
Sui Dynasty	581–618
Tang Dynasty	618–906
Five Dynasties	907–960
Liao Dynasty	907–1125
Song Dynasty	960–1279
Northern Song Period	960–1127
Southern Song Period	1127–1279
Jin Dynasty	1115–1234
Yuan Dynasty	1279–1368
Ming Dynasty	1368–1644
Qing Dynasty	1644–1911
Shunzhi	1644–1661
Kangxi	1662–1722
Yongzheng	1723–1735
Qianlong	1736–1795
Jiaqing	1796–1820
Daoguang	1821–1850
Xianfeng	1851–1861
Tongzhi	1862–1874
Guangxu	1875–1908
Xuantong	1909–1911
Early Republic	1912–1949
People's Republic	1949–present

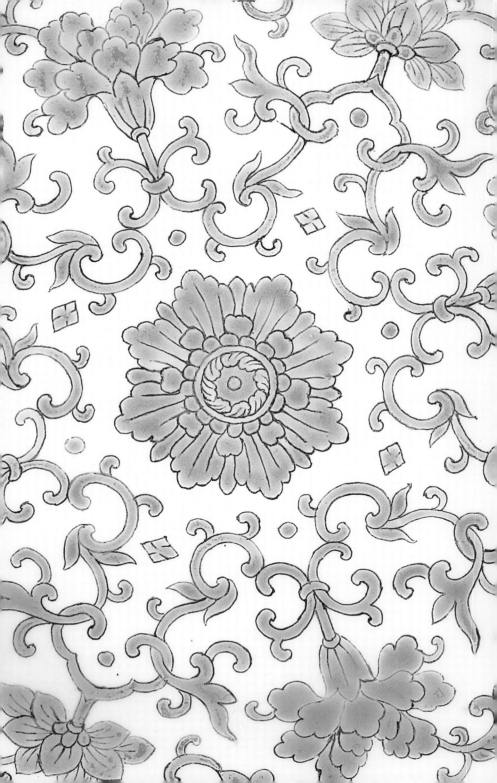

WORCESTER ART MUSEUM / www.worcesterart.org
Fifty-five Salisbury Street / Worcester, MA 01609 / 508.799.4406